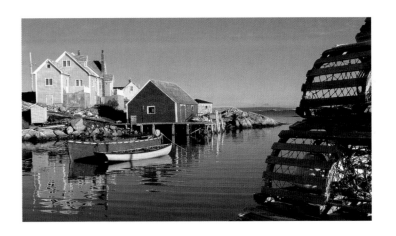

ATLANTIC
CANADA

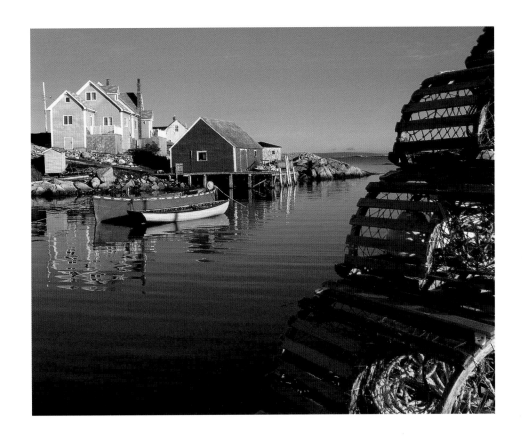

WHITECAP BOOKS
VANCOUVER / TORONTO

Cover and book design by Steve Penner
Cover photograph by Chris Cheadle / First Light
Text by Tanya Lloyd
Edited by Elaine Jones
Proofread by Lisa Collins
Photo editing by Pat Crowe

Printed and bound in Canada by Friesens, Altona, Manitoba.

Canadian Cataloguing in Publication Data
Lloyd, Tanya, 1973-
 Atlantic Canada

ISBN 1-55110-530-6

 1. Atlantic Provinces--Pictorial works. I. Title. II. Series:
Lloyd, Tanya, 1973-.
FC2004.L66 1997 971.15'04'0222 C96-910744-7
F1035.8.L66 1997

The publisher acknowledges the support of the Canada Council and the
Cultural Services Branch of the Government of British Columbia in making
this publication possible.

**For more information on this series and other Whitecap
Books titles, visit our web site at www.whitecap.ca.**

A tour of Atlantic Canada reveals spectacular coastlines carved by powerful storms and swift currents. It is a glimpse into the unique cultures of First Nations, Loyalists, Acadians, British, Dutch, Danish, Portuguese, and French settlers. It is a journey by smuggler's raft, fishing boat, and military ship into a fascinating part of Canadian history.

Long before the arrival of European settlers, Atlantic Canada supported a thriving fishery. The Micmac First Nation harvested fish, shellfish, and seabird eggs from Nova Scotia shores and the Beothuck fished and hunted seals in the bays of Newfoundland. Until recently, First Nations people were believed to be the only inhabitants of the Atlantic region before the arrival of John Cabot in 1497. But in 1960, Norwegian Helge Ingstad discovered L'Anse aux Meadows, the remains of a Norse settlement established 500 years before Cabot's arrival.

Since these Viking explorers first sailed to these shores, the Atlantic provinces have attracted settlers from around the world. The Acadians were the next to take up residency, building dykes and farming the rich soil surrounding the Bay of Fundy. After more than a hundred years on Canadian soil, the Acadians were banished by the British in 1755 when they refused to swear allegiance to the British crown.

Today, there are more descendants of Loyalists than of Acadians in the Atlantic region. When the United States declared independence, 15,000 British supporters flocked north, establishing cities like Saint John, New Brunswick, and spurring growth across the region.

As one of the earliest parts of Canada to be settled, the Atlantic provinces boast an eclectic array of historical milestones. Nova Scotia hosted Canada's first play and first representative government. Thanks to Alexander Graham Bell, the country's first manned air flight took off from Baddeck, Nova Scotia, in 1909, just eight years after Guglielmo Marconi received the first radio transmission at Signal Hill in Newfoundland.

Throughout the Atlantic, governments have set aside many historic sites and parks to preserve the region's natural and scientific history. From the foundations of the Citadel to the unique saltwater habitat of the Tantramar Marshes, there is much to explore. In *Atlantic Canada*, you can walk high above a spectacular fjord, or walk back through history to the battles of Louisbourg and the taverns of St. John's.

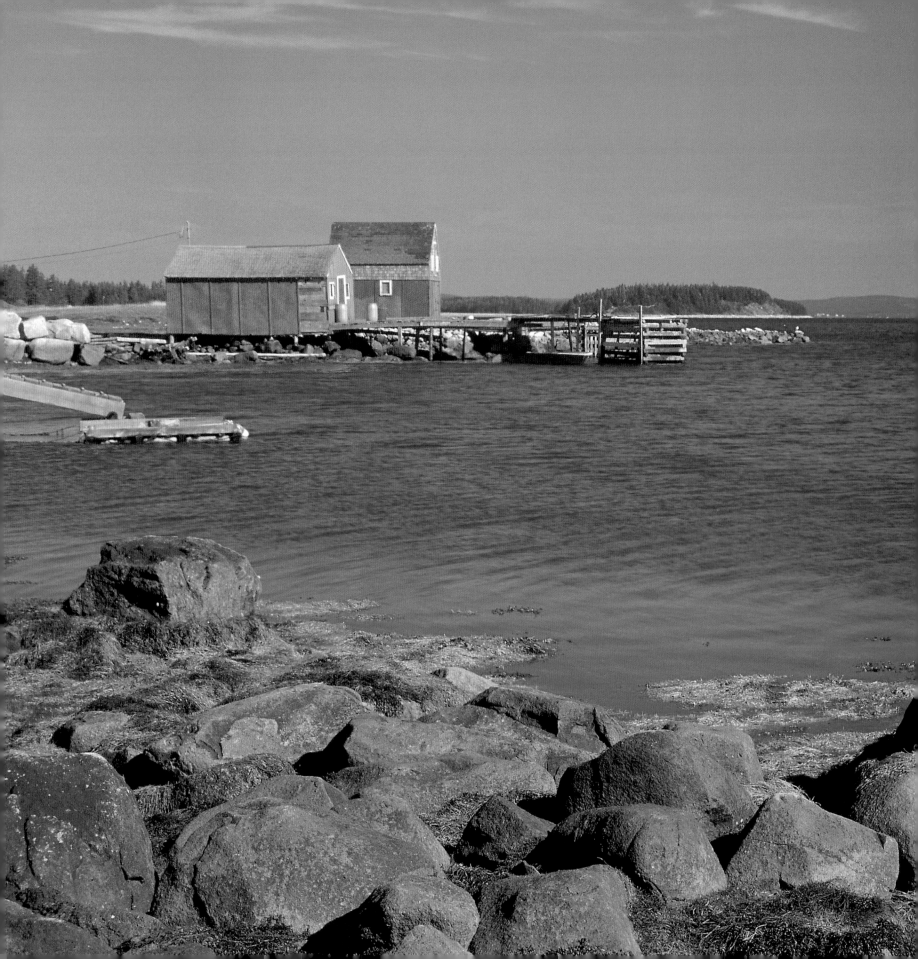

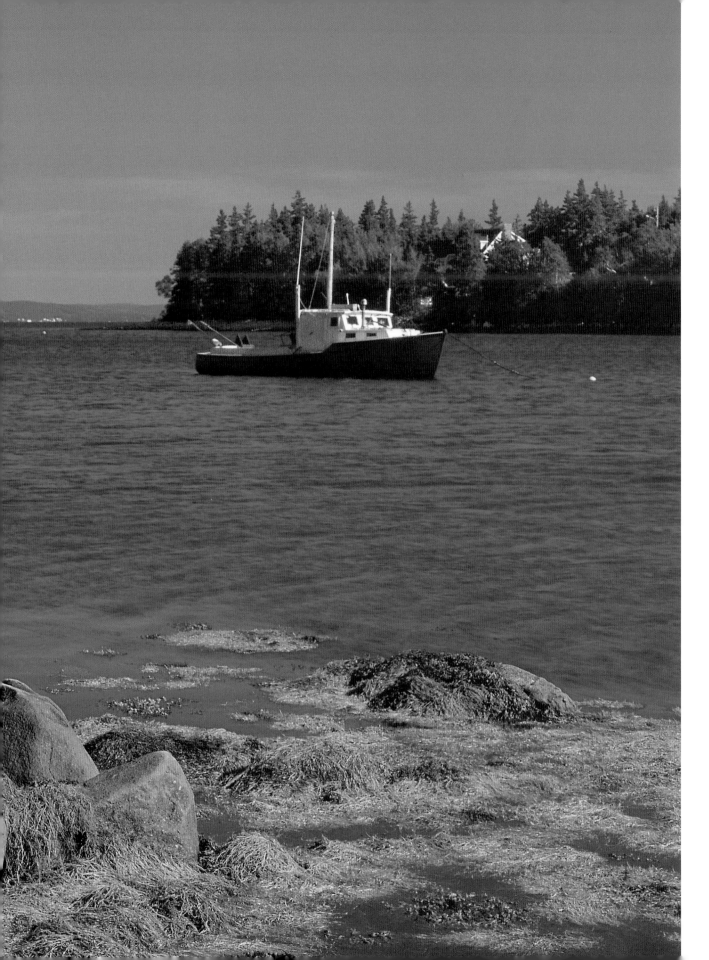

Picturesque communities, such as Seabright and French Village, line the shores of St. Margarets Bay in Nova Scotia. Visitors know this area, with its treacherous cliffs and rocky shores, as the "Lighthouse Route."

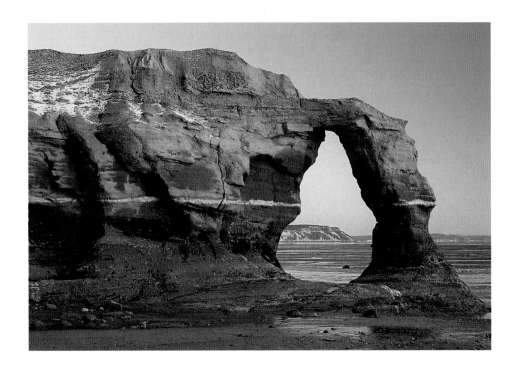

In North Medford, a sandstone arch frames a view of Cape Blomidon. Nova Scotia has nearly 6000 kilometres of coastline. Only a narrow isthmus connects the province to New Brunswick.

Cape LaHave Island and the nearby cape were named for Cap de la Hève, near Le Havre, France. From 1632 to 1636, the town of La Have was the capital of Acadia, a primarily French-speaking agricultural society and Canada's first major European settlement.

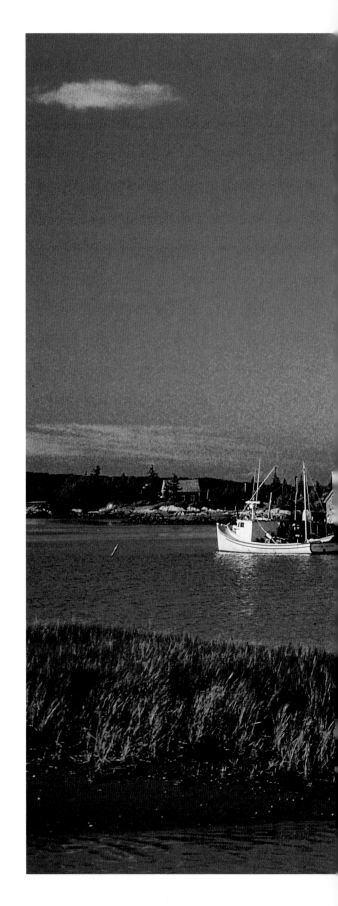

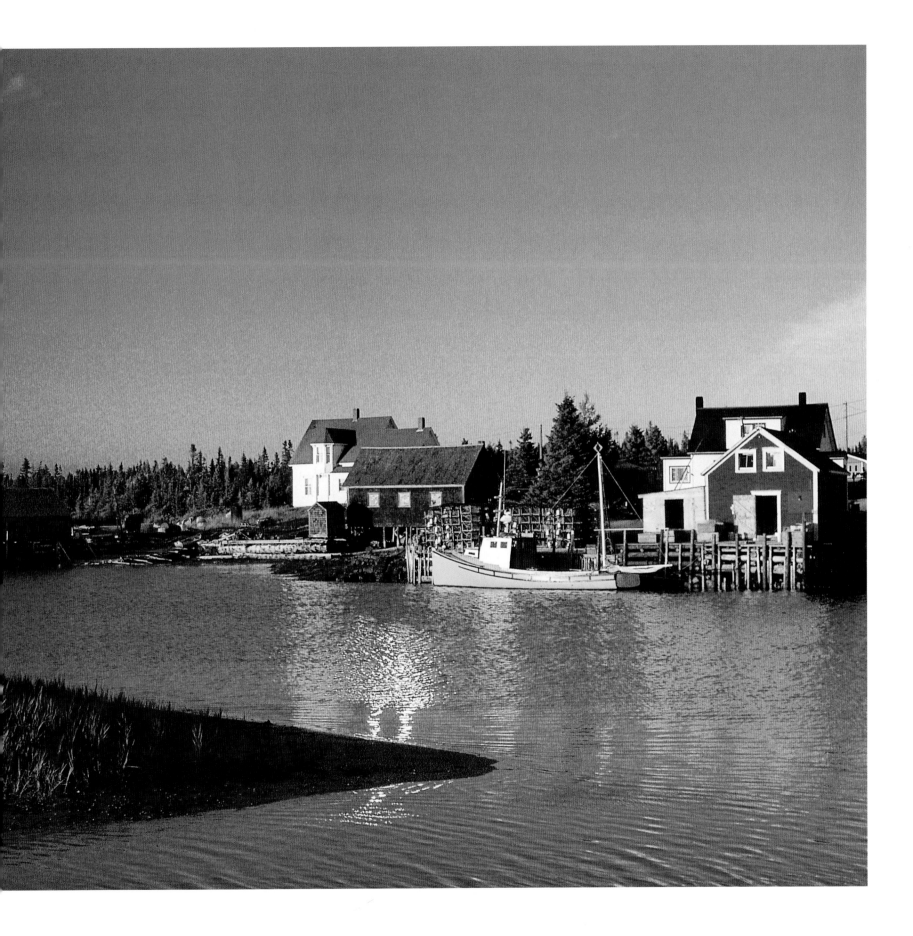

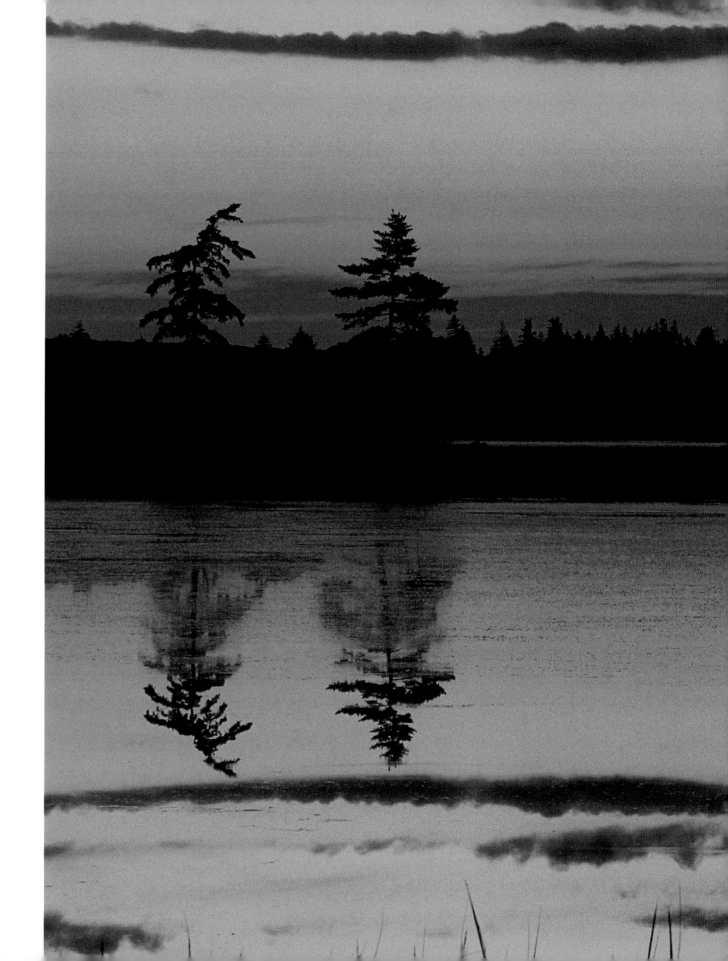

One of the last undeveloped stretches of Nova Scotia's coastline is a refuge for Atlantic birds and wildlife.

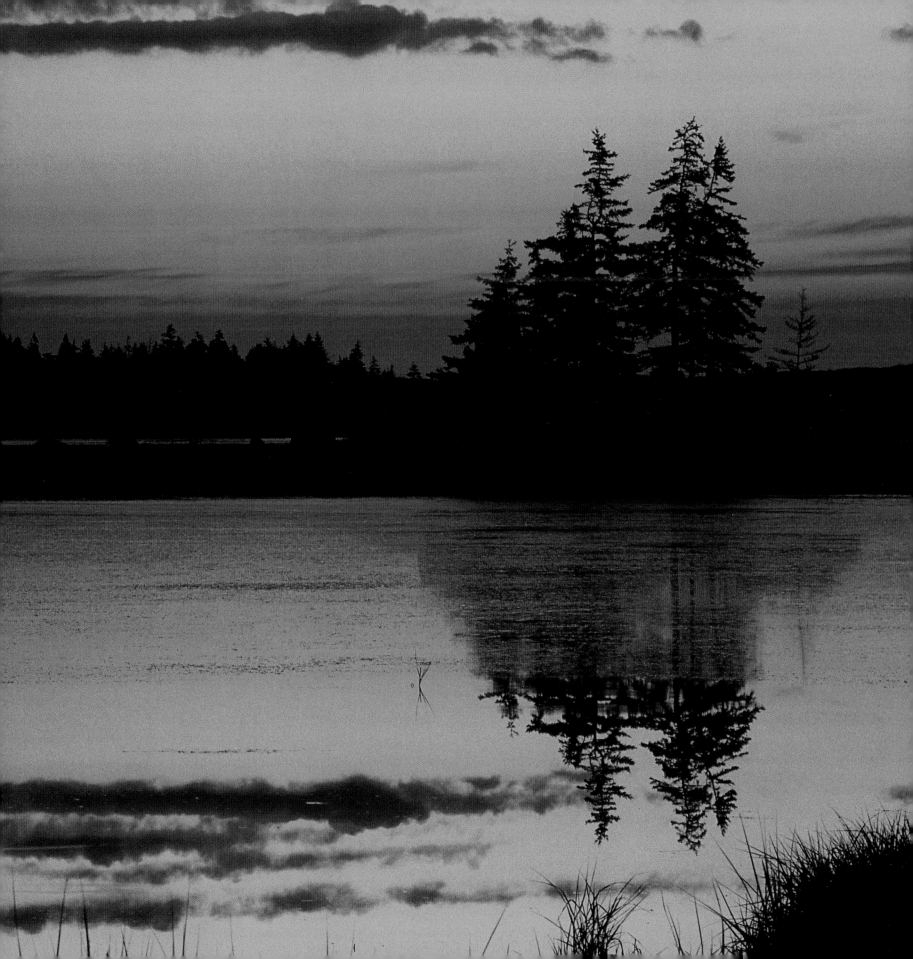

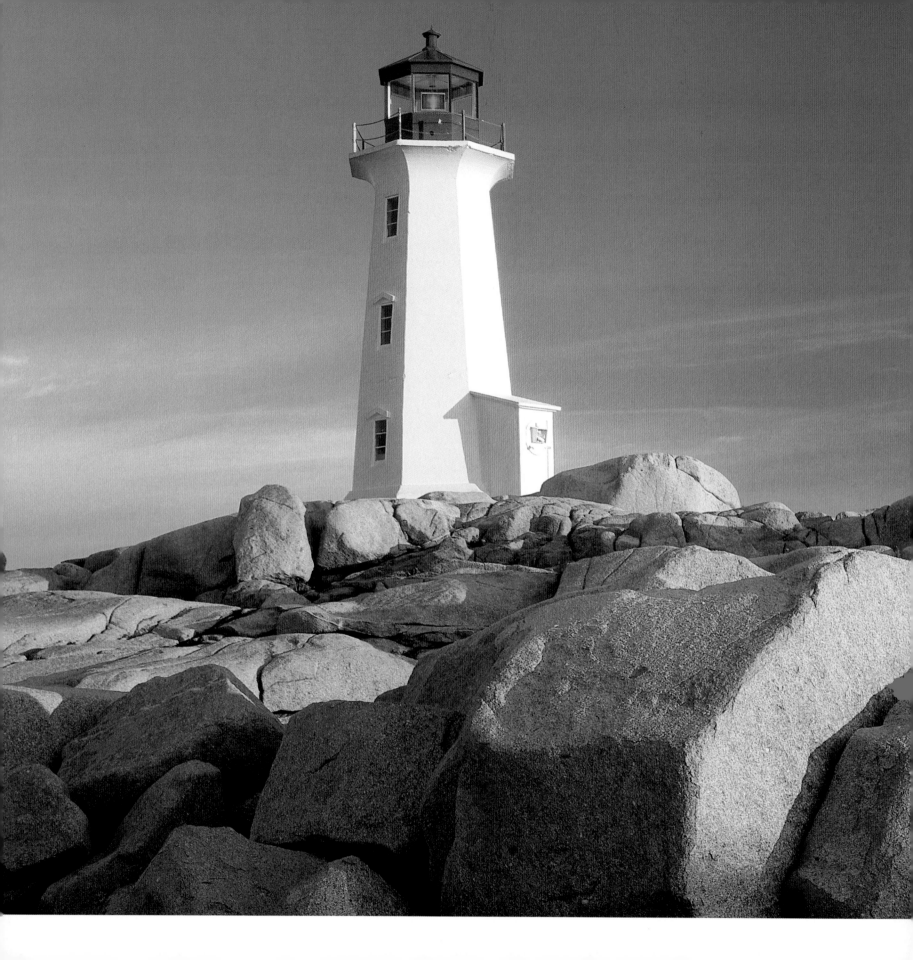

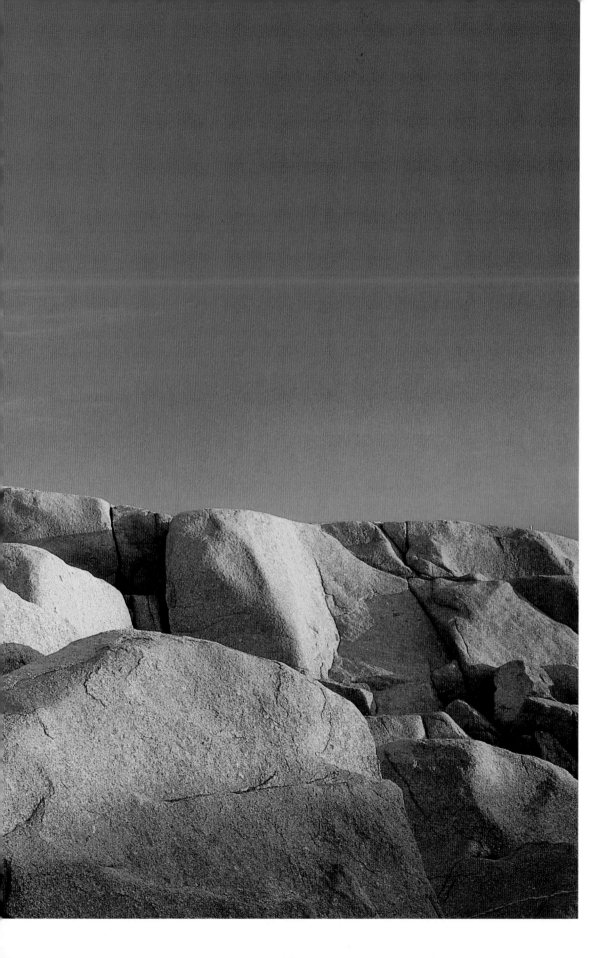

One of Atlantic Canada's most photographed places, Peggy's Cove preserves a romantic view of Nova Scotia's seafaring past. The setting is not so peaceful in a storm—visitors have occasionally been swept off these rocks by giant ocean swells.

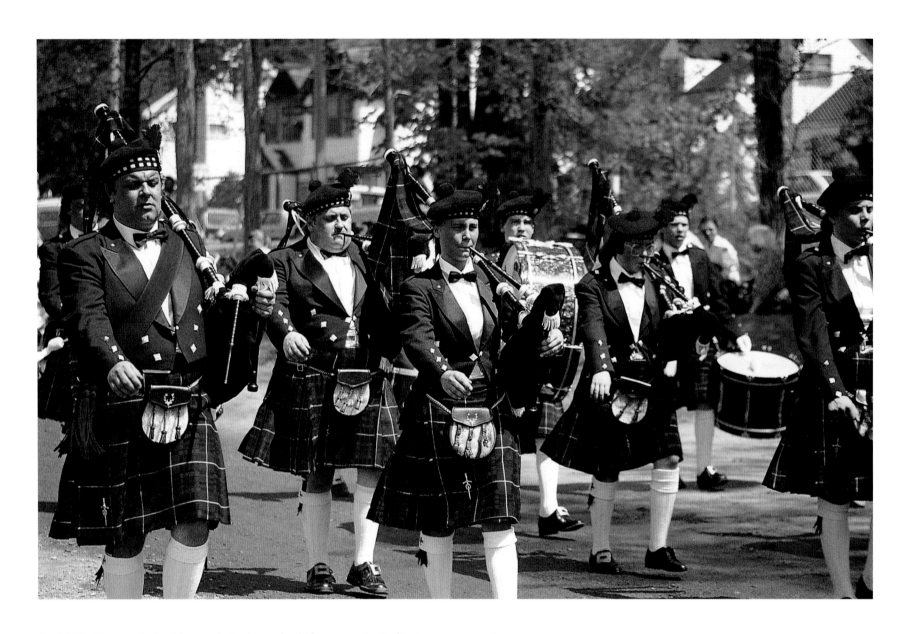

In 1605, Samuel de Champlain founded the country's first permanent settlement in the Annapolis Valley. He was followed by settlers from Britain, France, and around the world. Pipers in the valley's Apple Blossom Festival parade serve as a reminder of the province's Scottish heritage.

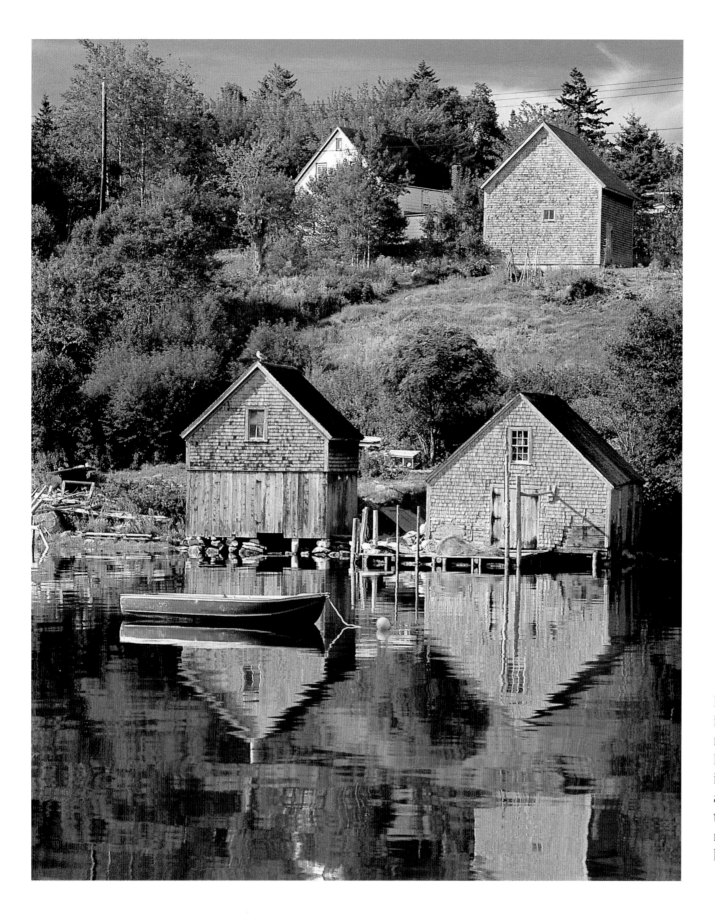

No part of Nova Scotia is more than 56 kilometres from the sea. Boats, docks, and fishing nets can be found at every village along the coast and along many of the province's lakes and rivers.

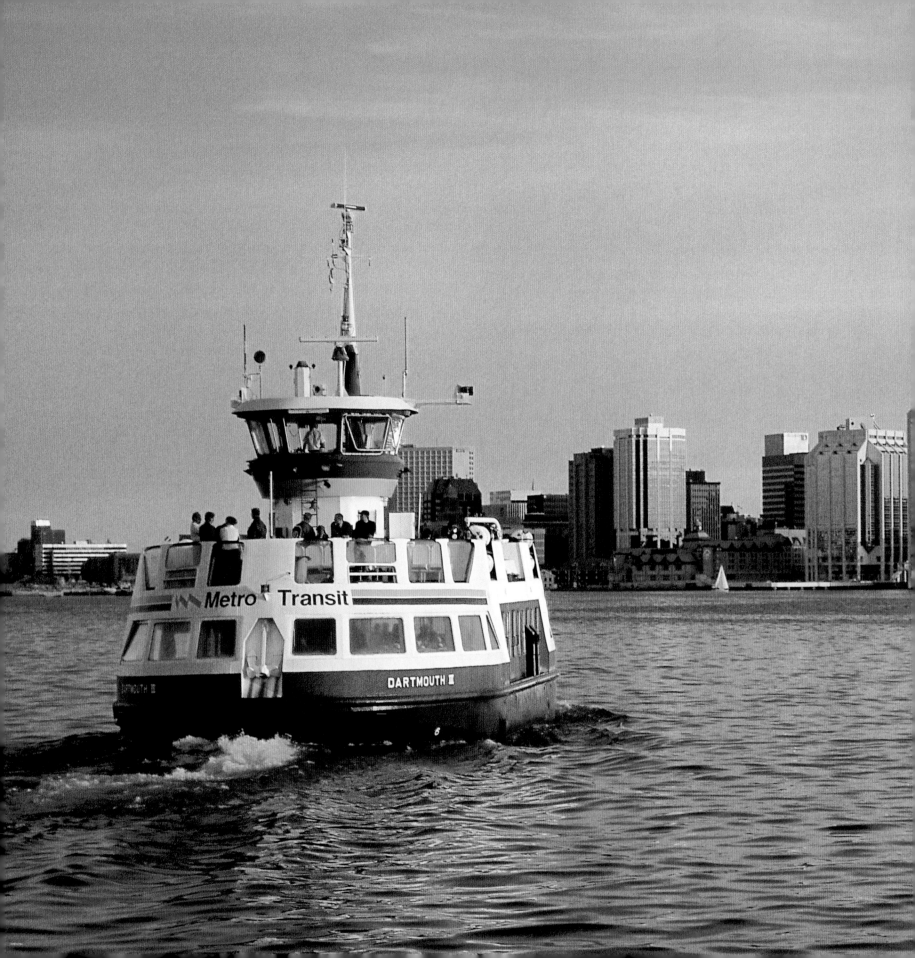

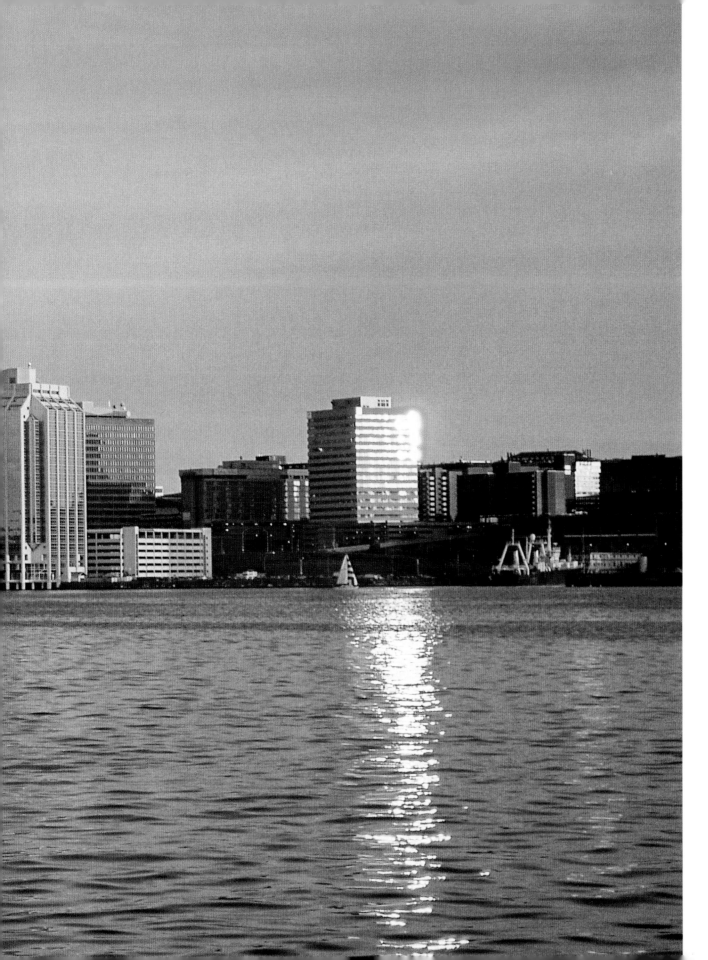

Small ferries shuttle commuters and visitors across the harbour between Halifax and Dartmouth. The buildings surrounding Halifax Harbour were destroyed in 1917 when a French munitions ship exploded. It was the largest non-nuclear explosion in history, killing about 2000 people.

The Bluenose was built in 1921 and earned fame as a racing schooner. The Bluenose II, a replica, can be seen in Halifax or, more often, in its home port of Lunenburg, Nova Scotia.

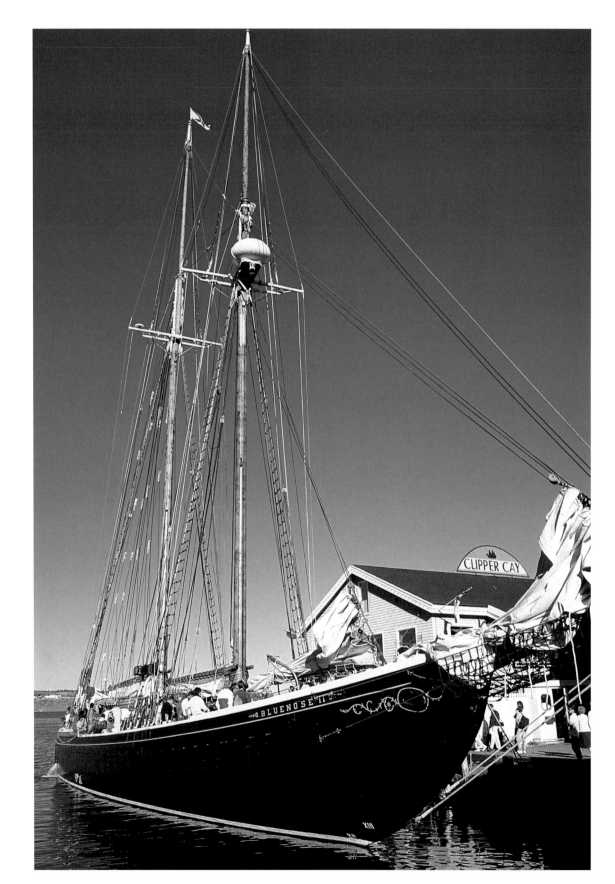

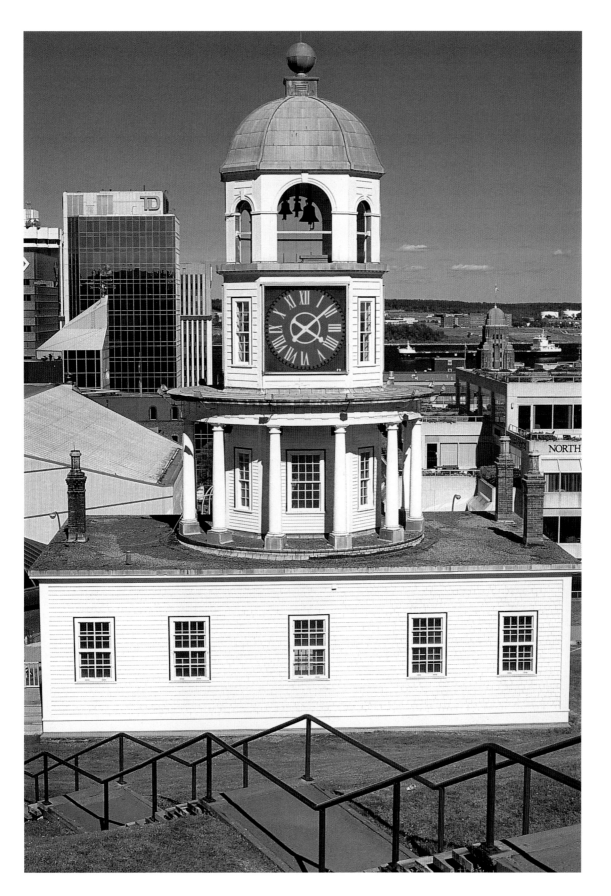

Near the base of Citadel Hill, the Old Town Clock tells the time as well as it did in 1803, when it was built by order of Prince Edward, the son of George III.

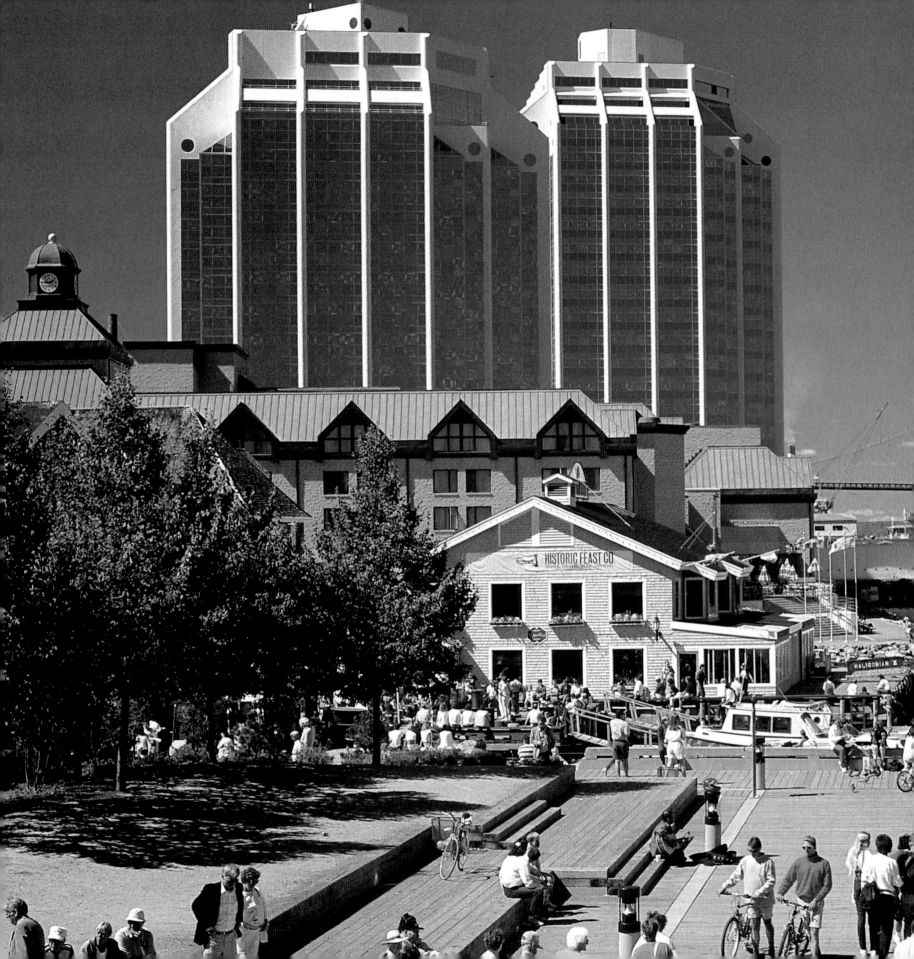

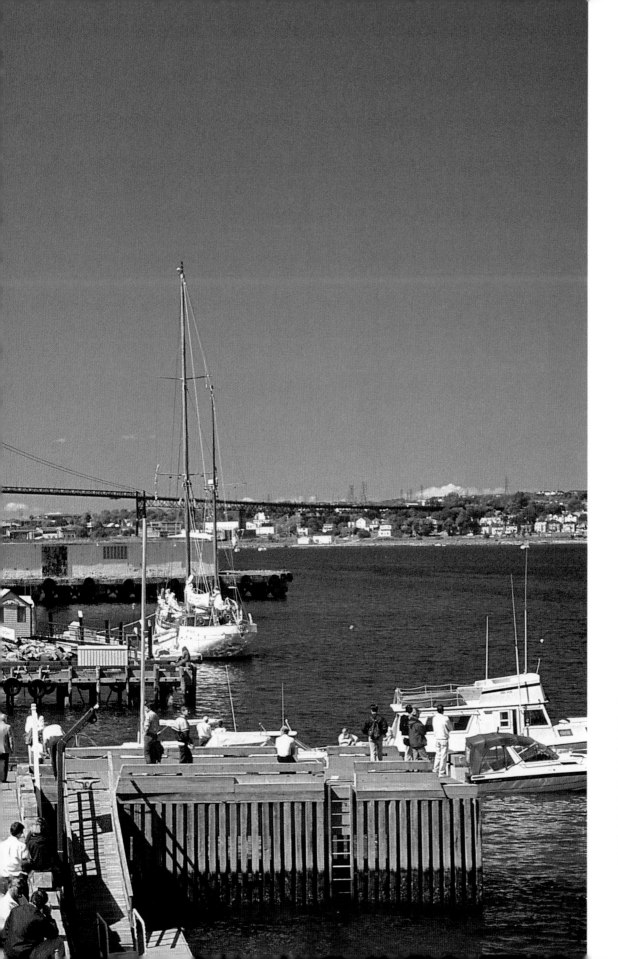

The nineteenth-century
buildings of Halifax's Historic
Properties were once the
neighbourhood of Enos Collins,
a smuggler, shipper, and local
businessman. Collins was an
important figure in the Halifax
Banking Company, which later
became the Royal Bank.

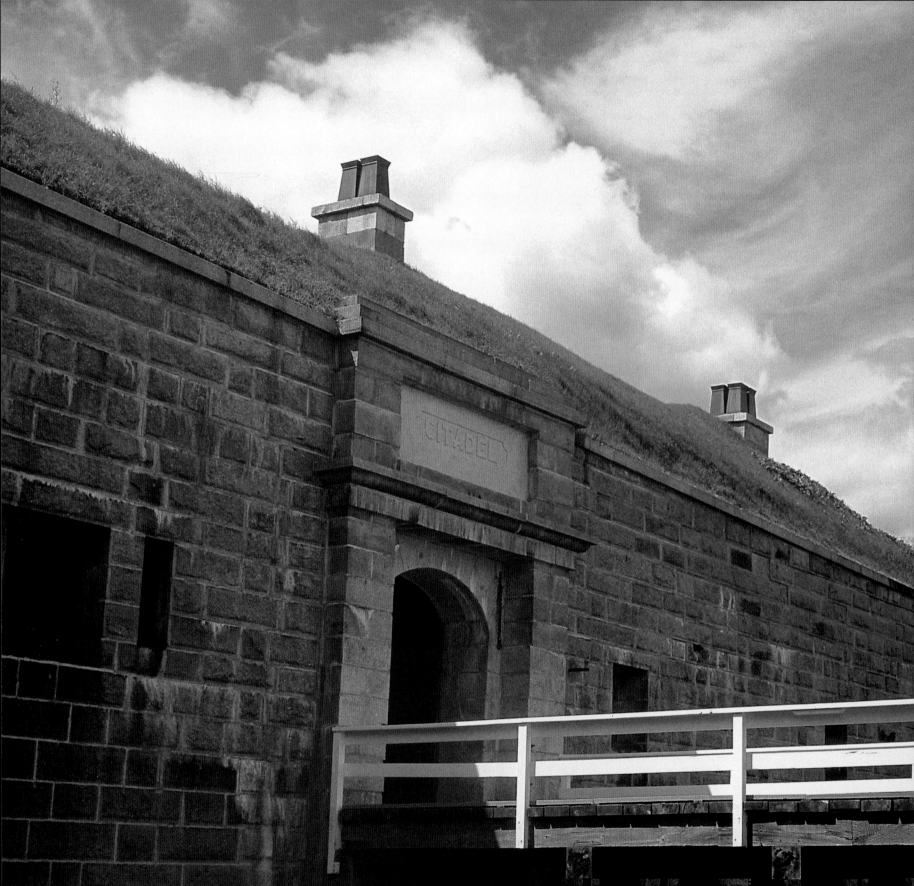

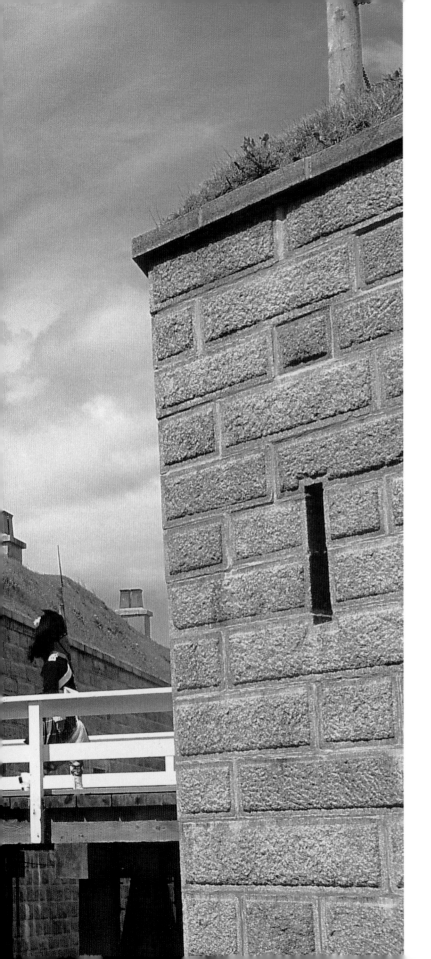

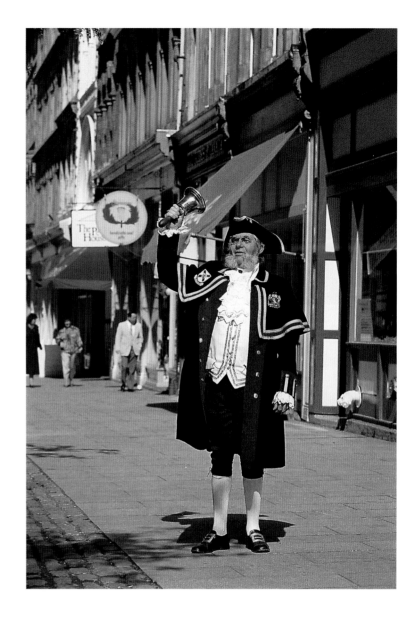

A town crier at Halifax's Granville Mall brings history to life. Nova Scotia is home to a number of historical firsts, including Canada's first play, printing press, representative government, and, more recently, the first power station to generate electricity from the tides.

British forces built the Citadel in 1749 to counter the French fortress of Louisbourg on Cape Breton Island. The star-shaped Citadel was the stronghold of Halifax's fortifications and the beginning of the area's long military history. Today, navy ships still share the harbour with freighters and pleasure boats.

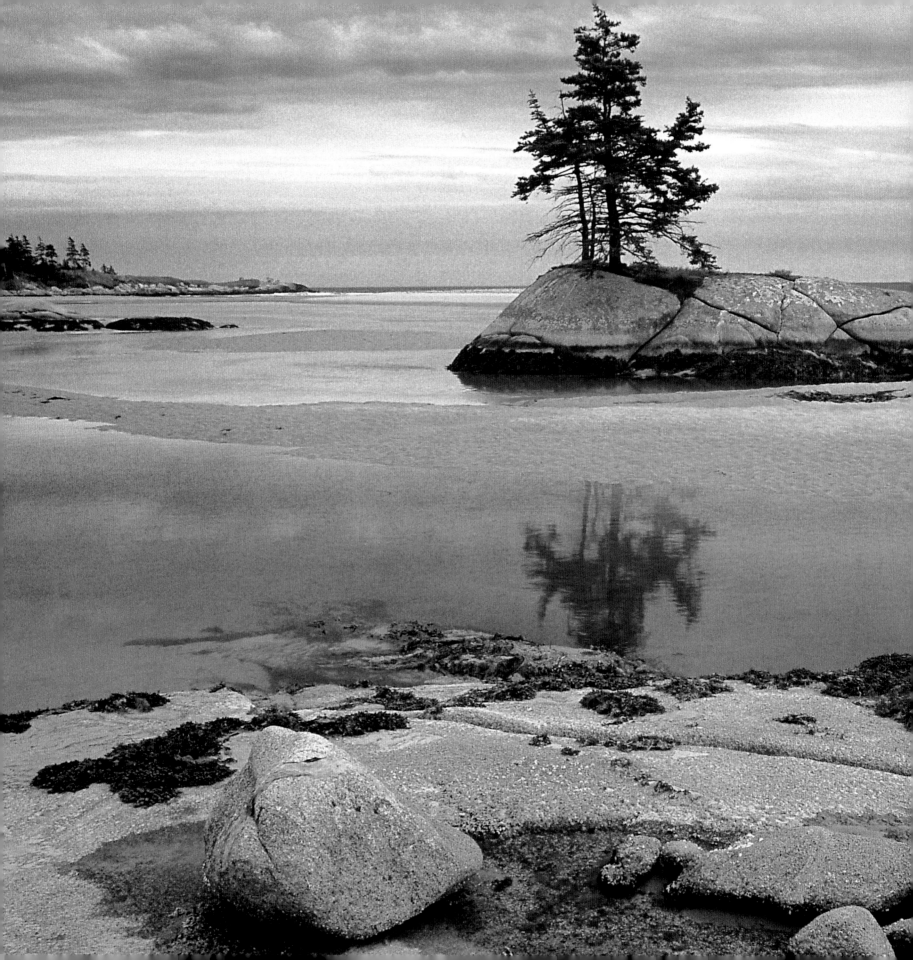

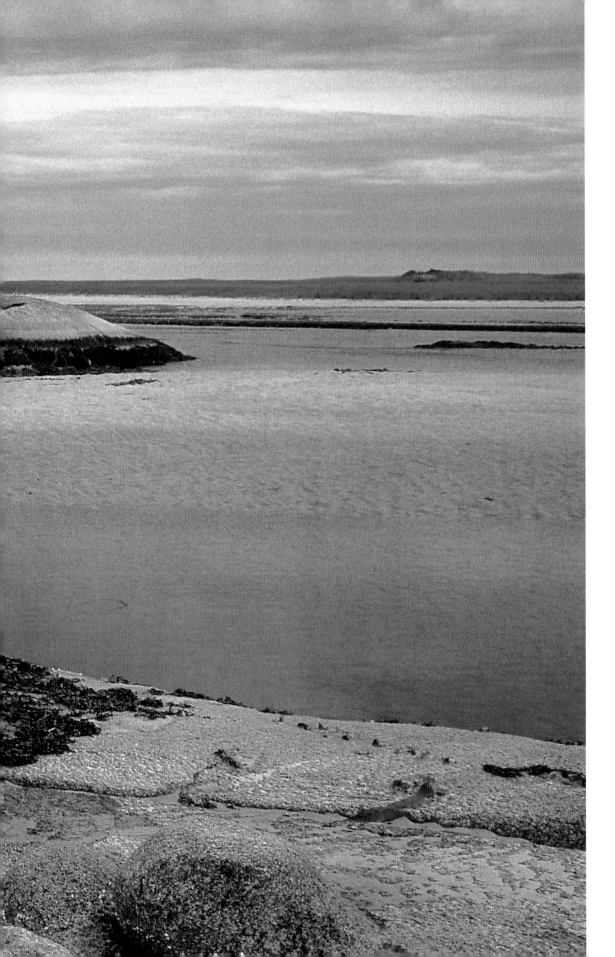

St. Catherine's River Beach, one of the isolated stretches of Kejimkujik National Park, is a popular summer escape for sunbathers. In winter, visitors avoid the long walk to the beach and the area remains mostly deserted.

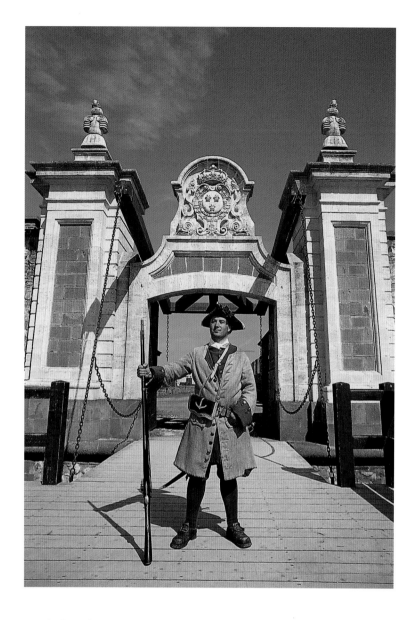

Built by the French, captured by the New Englanders, and destroyed by the British, the Fortress of Louisbourg played a fascinating role in Canadian history. Its destruction in 1760 signalled the end of France's hold on the colony. The fortress has been rebuilt and designated a national historic site.

The jagged cliffs of Cape d'Or divide the Bay of Fundy and the Minas Basin. They provide a spectacular view of the currents and swells caused by the tides.

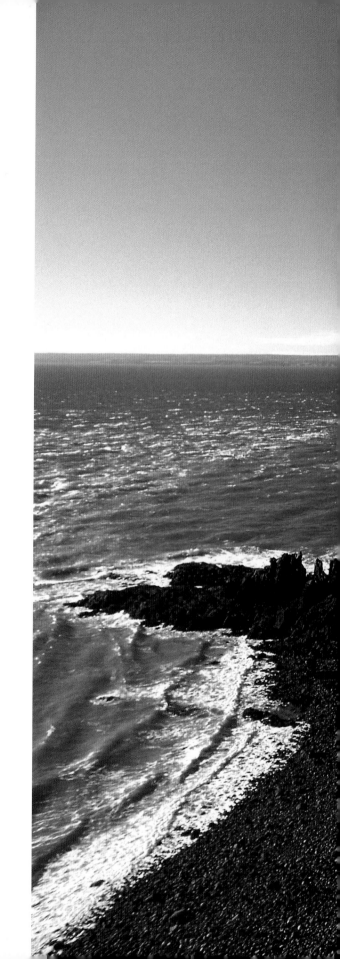

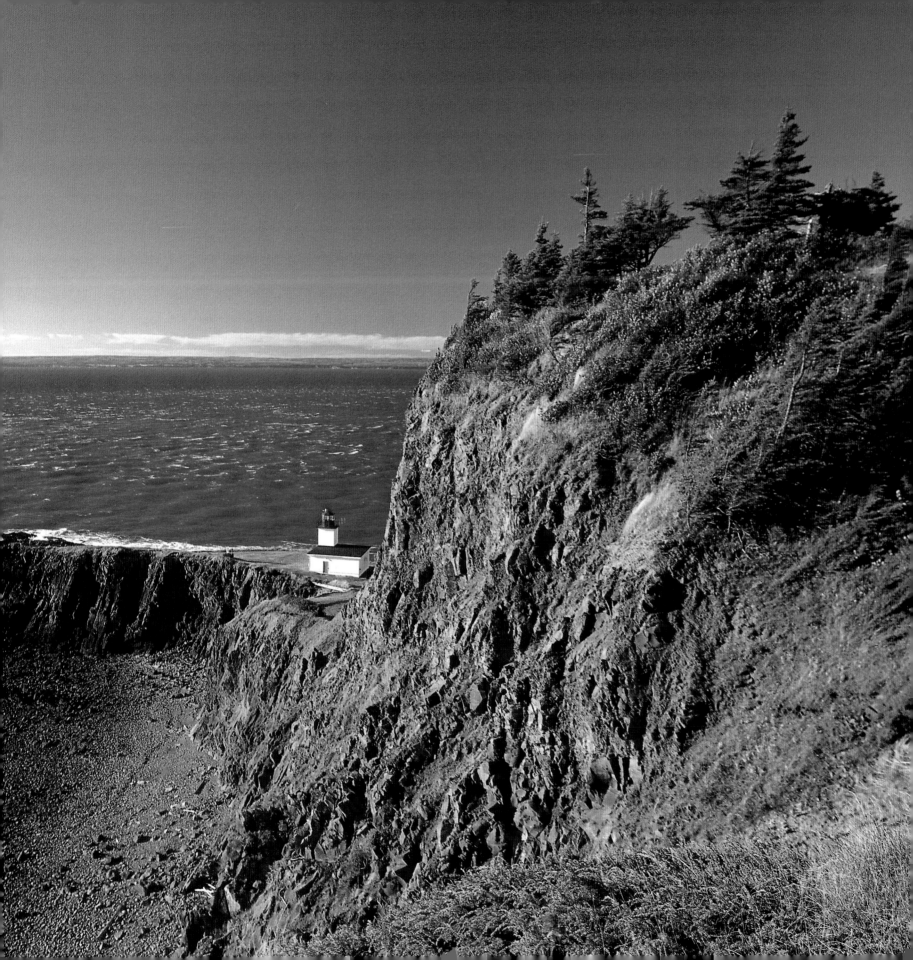

In Cape Breton Highlands National Park, Mary Ann Falls pours over granite boulders left by the last ice age. More than 20 hiking trails crisscross the park, winding through groves of yellow birch, beech, and sugar maples hundreds of years old.

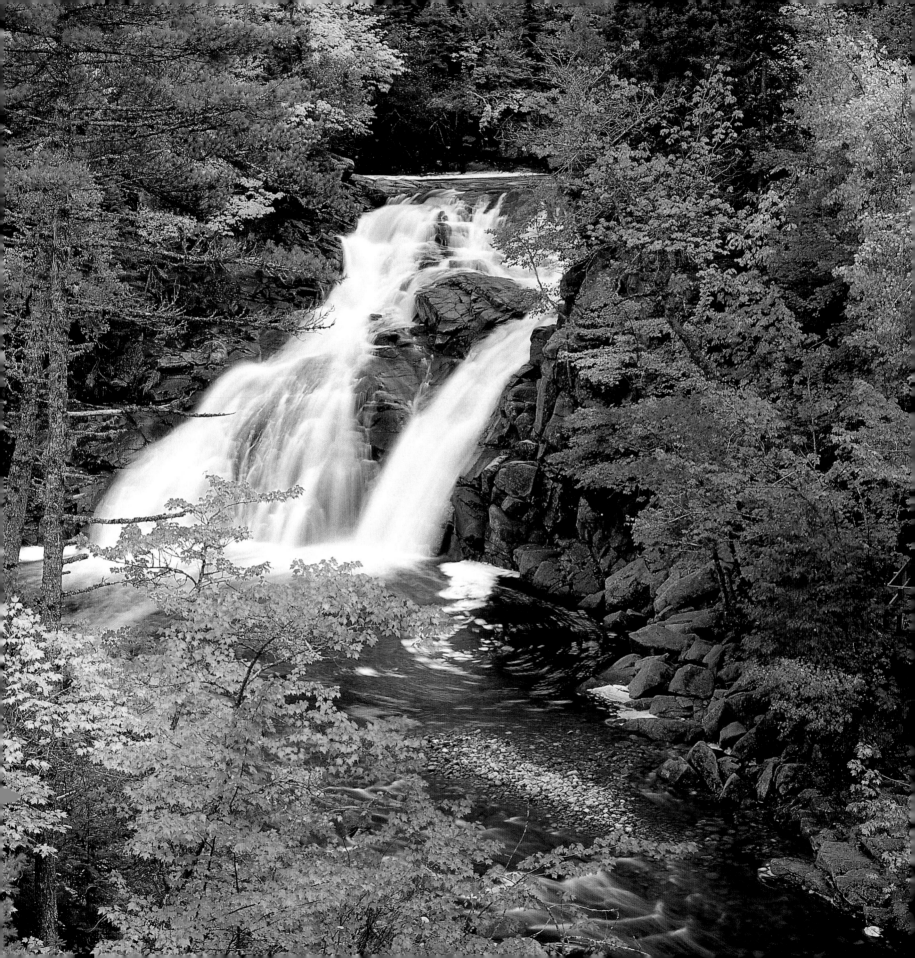

One of the most dramatic drives in Canada, the 294-kilometre-long Cabot Trail winds through Cape Breton Highlands National Park and circles the northern part of the island, allowing visitors a stunning view of coastal cliffs and beaches. Some Cape Breton residents claim that John Cabot landed on the island in 1497; Newfoundlanders disagree.

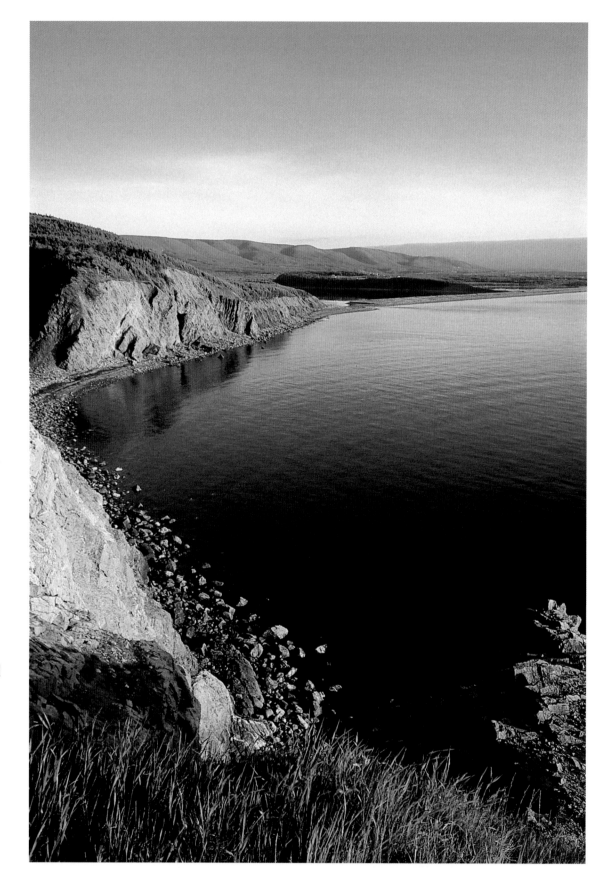

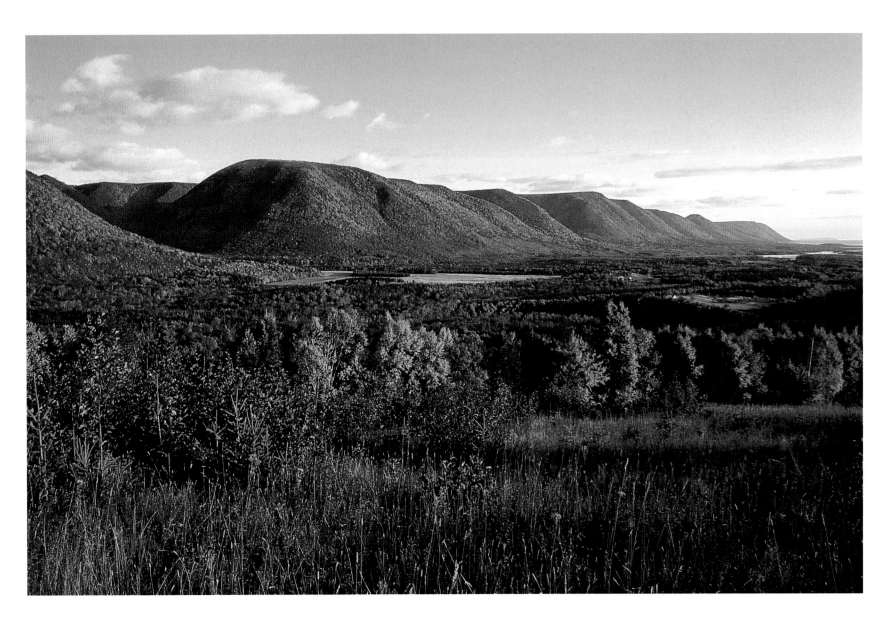

North Aspy Valley on Cape Breton Island is known as Sunrise Valley for the beauty of its morning views.

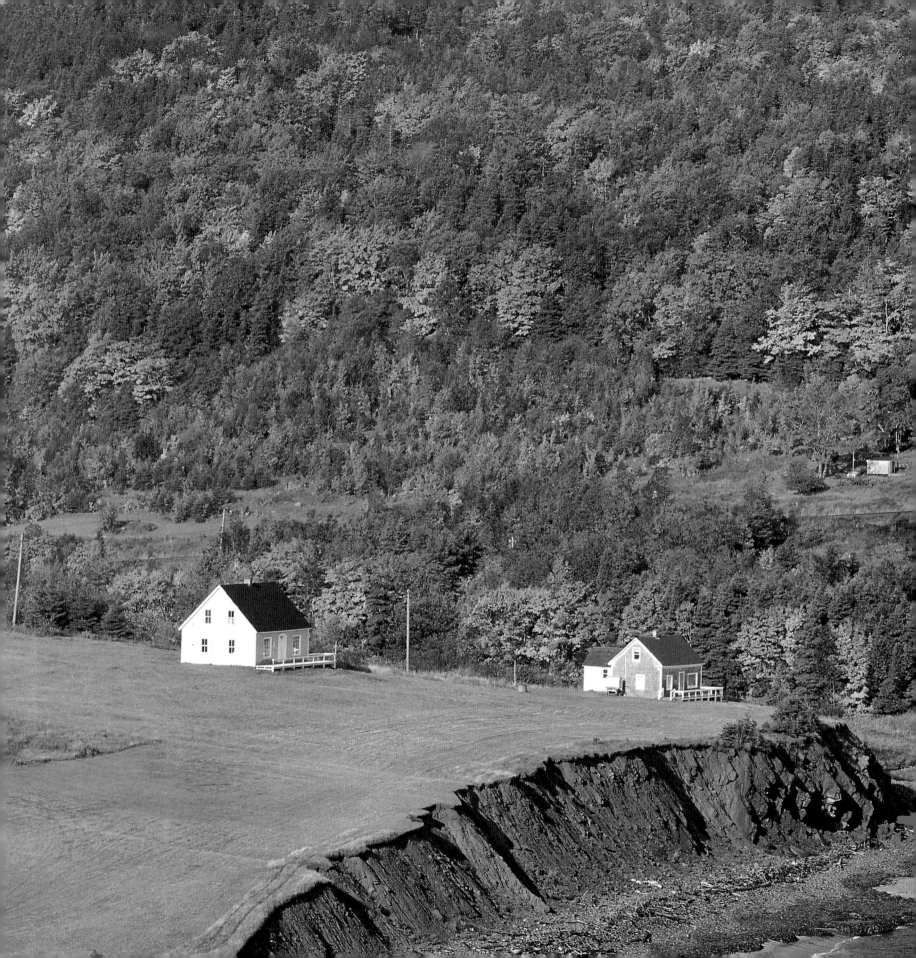

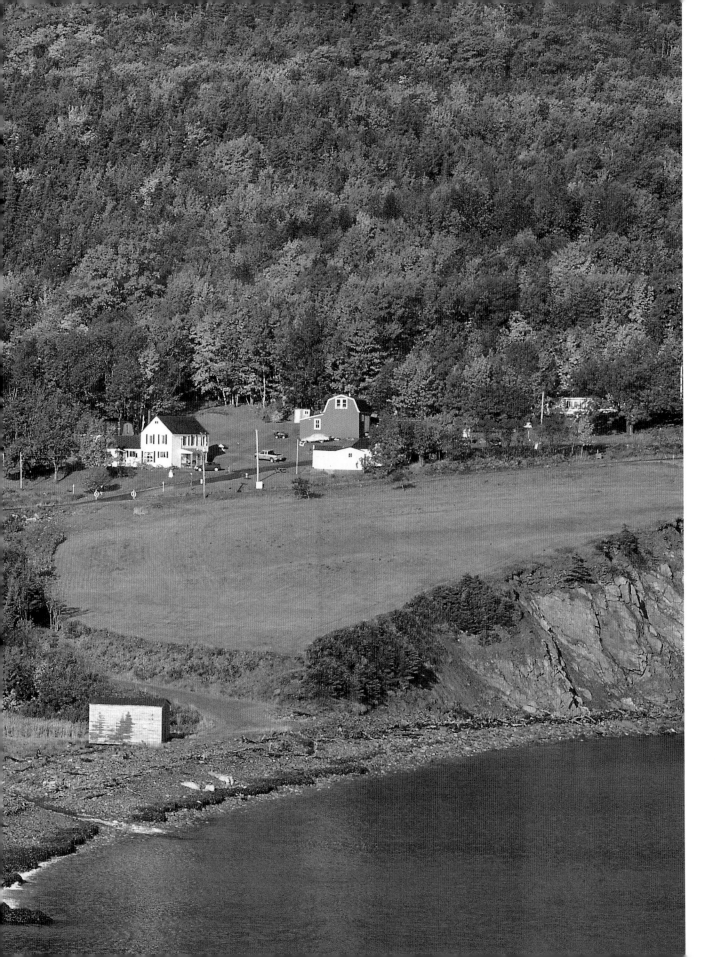

Farmland and forest
stretch along the
Atlantic near Capstick,
at the northern tip of
Cape Breton Island.

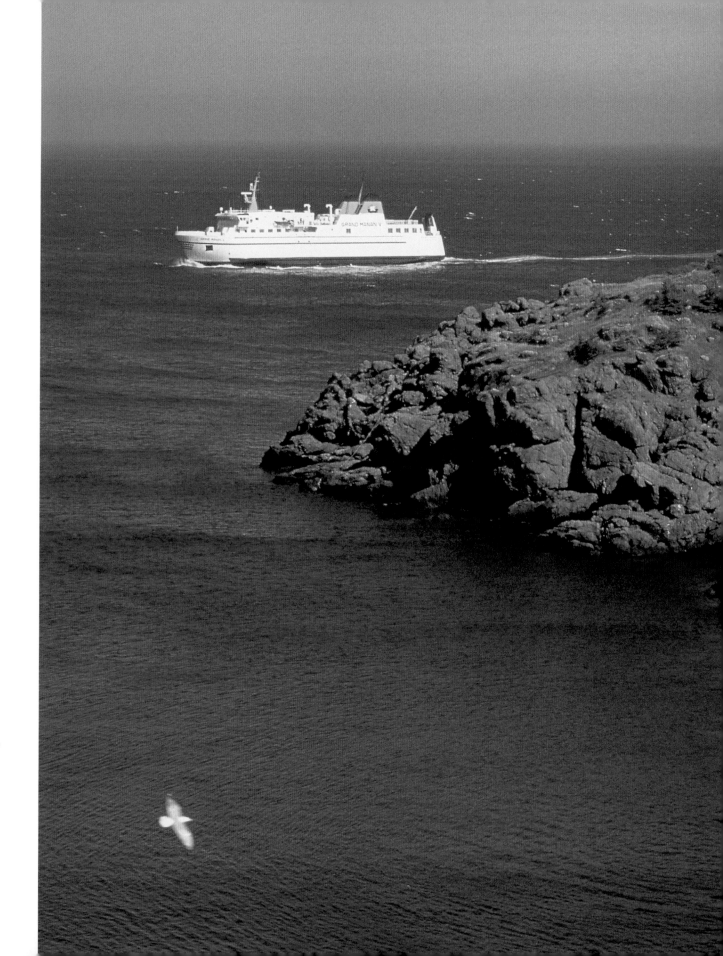

The seabed around New Brunswick's Grand Manan Island is strewn with sunken ships, caught in the treacherous currents caused by high tide. Swallowtail Lighthouse is one of four beacons that warn approaching vessels of the danger.

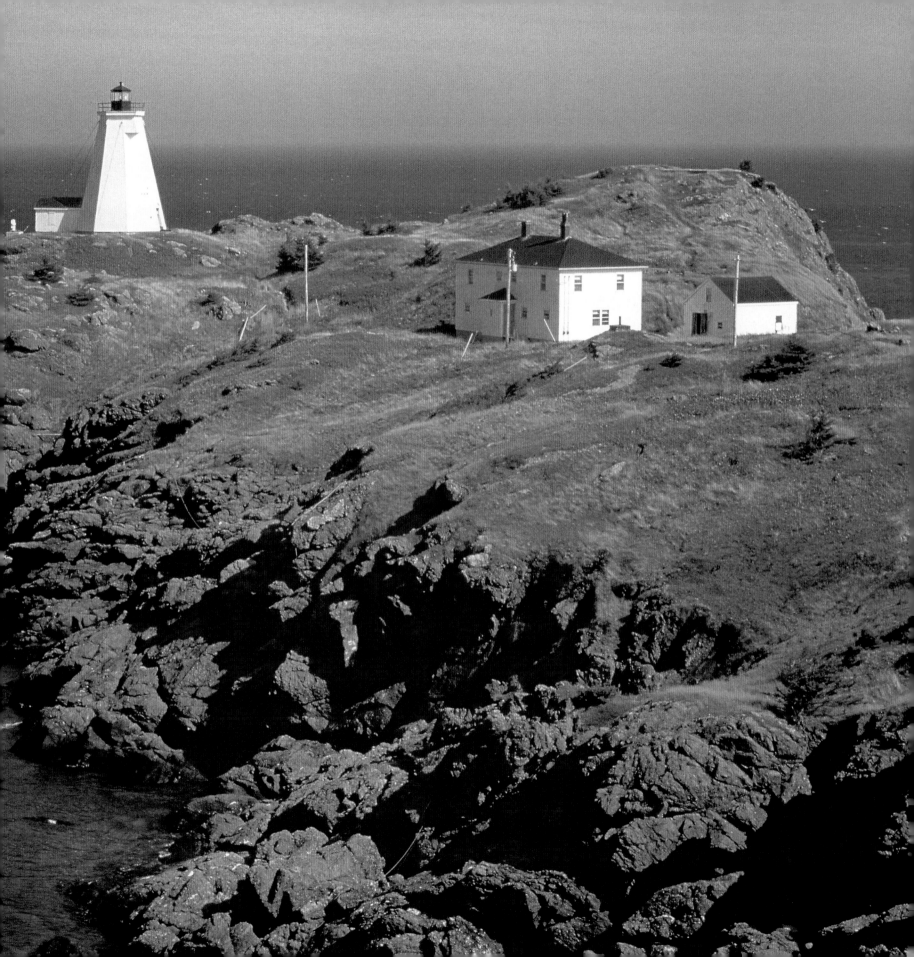

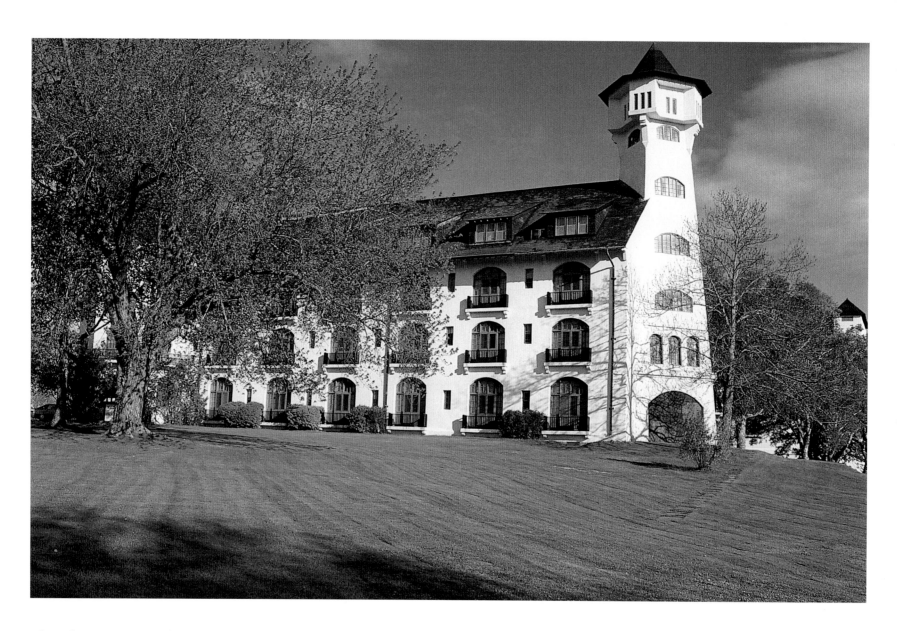

The Algonquin Hotel at St. Andrews-by-the-Sea was
built by local businessmen but bought in 1902 by Sir
William Van Horne and Sir Thomas Shaughnessy,
famous for their roles in the Canadian Pacific Railway.
Under their management, the Tudor Revival style
hotel became a major resort and tourist destination.

Right, finback, humpback, and minke whales
feed off the herring and plankton around
Grand Manan Island. The rugged cliffs above
are home to numerous bald eagles.

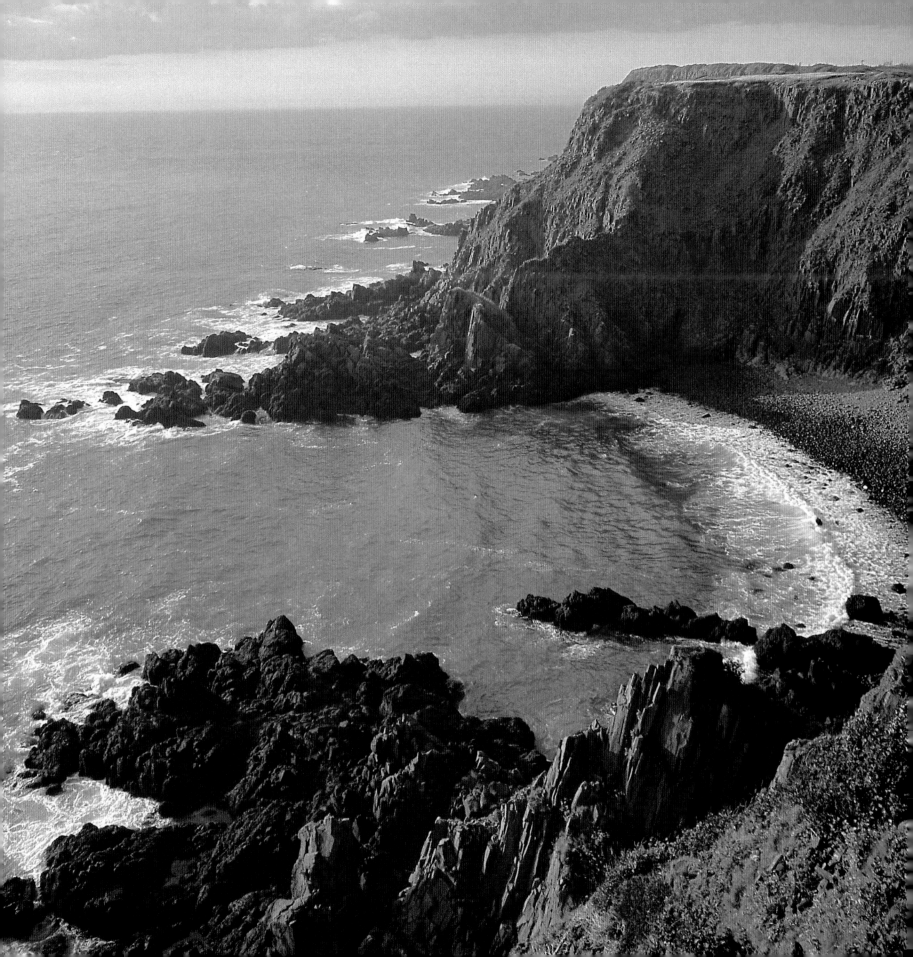

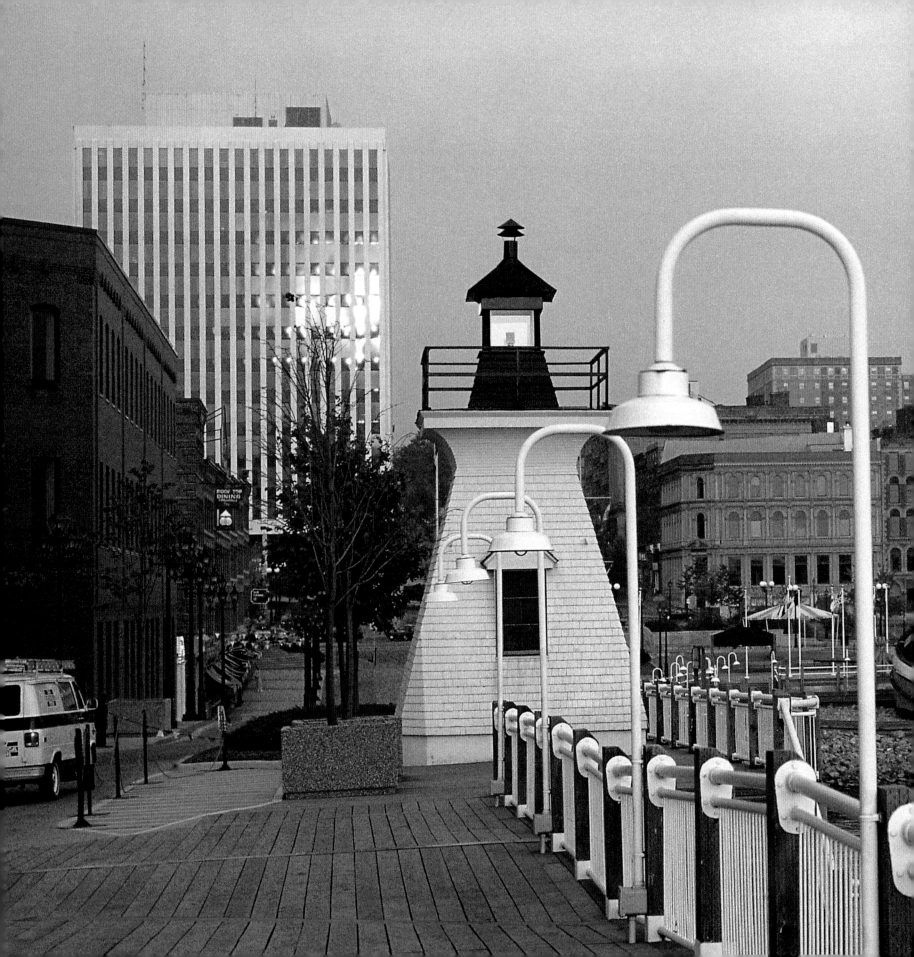

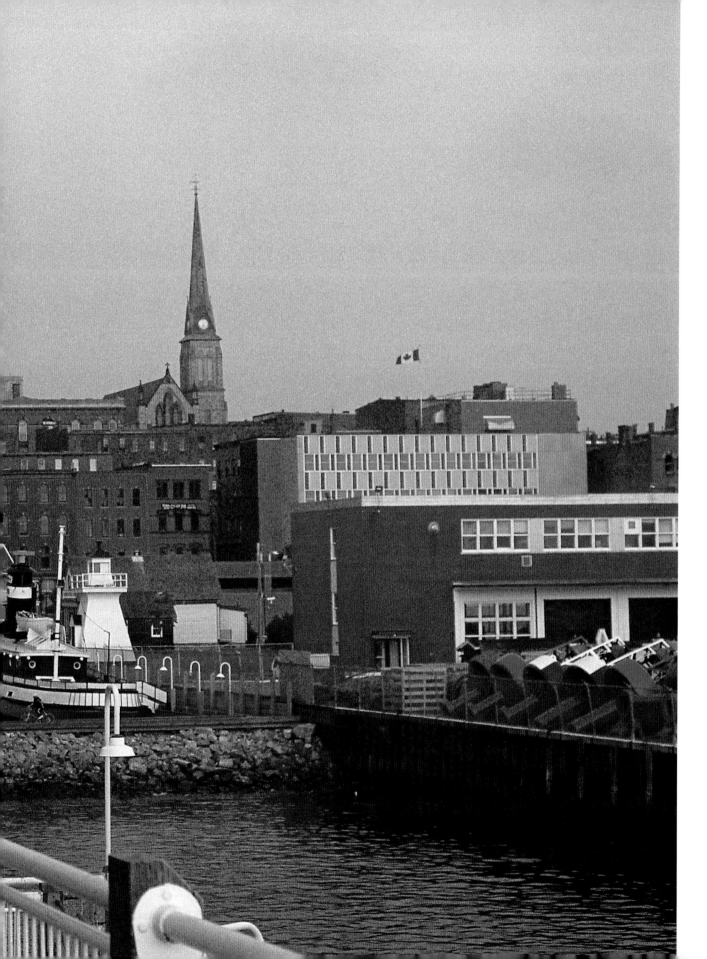

In the late 1700s, 15,000 Loyalists flocked to New Brunswick from the newly independent United States. Saint John was just one of the communities they founded. In 1785, it was the first city to be incorporated in British North America.

OVERLEAF –
The world's highest tides—sometimes reaching more than eight metres—sweep through the Bay of Fundy.

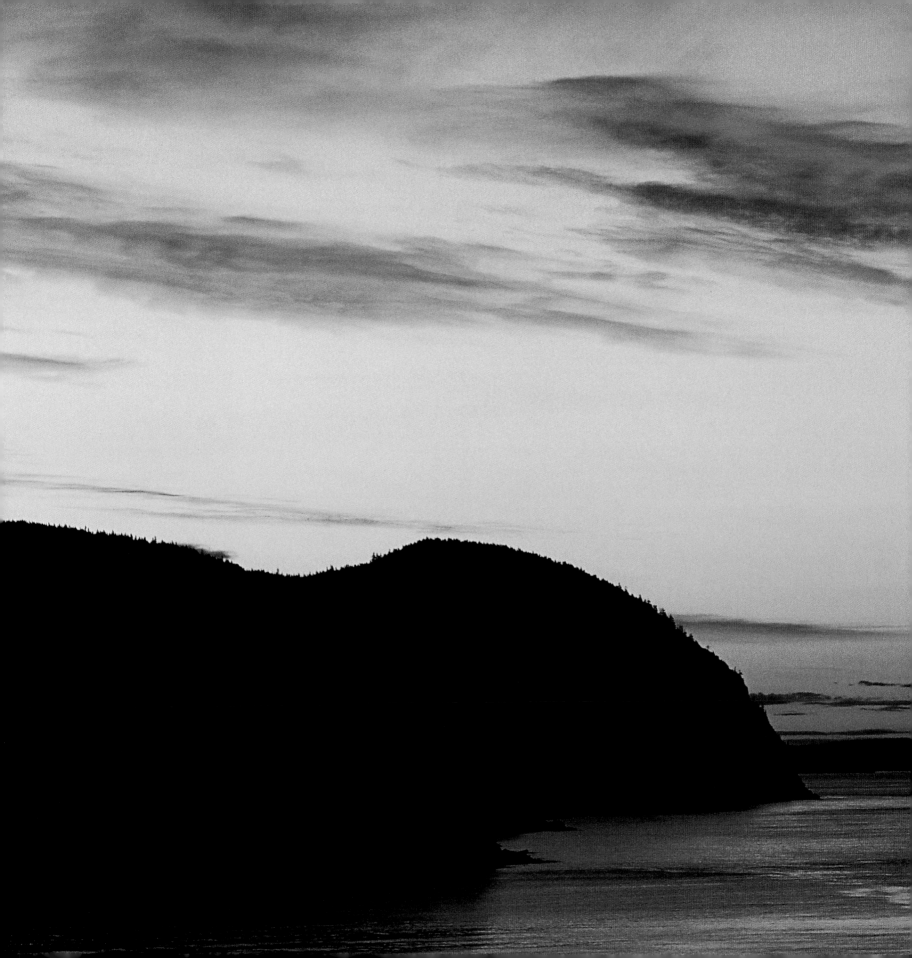

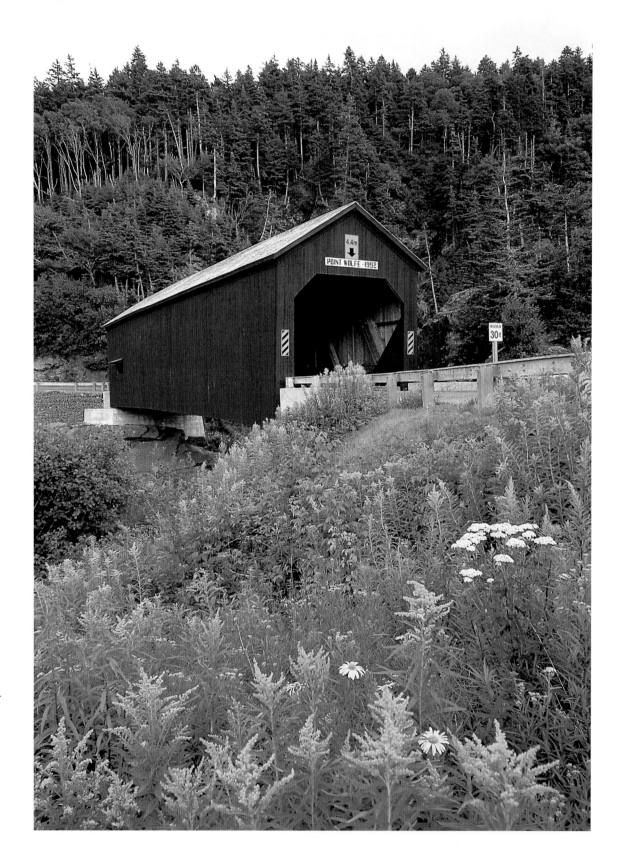

Point Wolfe bridge is one of two covered bridges in Fundy National Park. This is actually a reconstruction—a work crew accidentally blasted the old bridge in 1990.

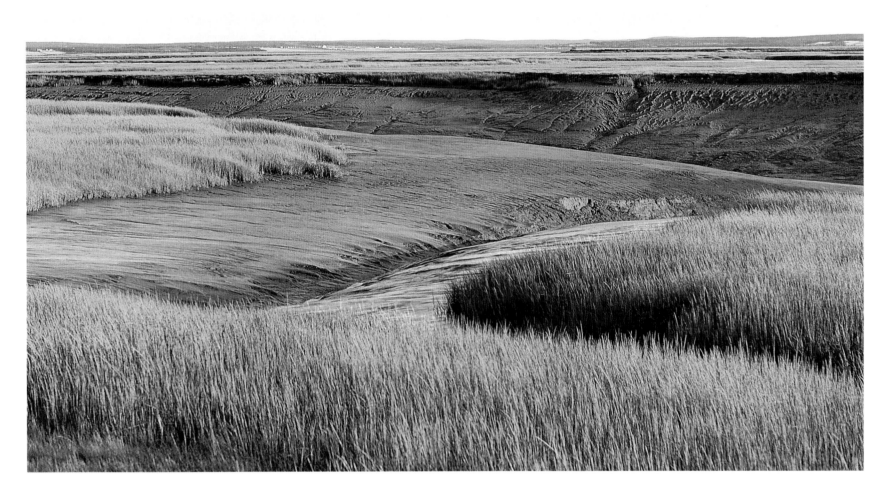

The name of the Tantramar Marshes comes from the French word *tintamarre*, which means the sound of birds taking flight. Conservation is encouraged in the area through nature walks, calling competitions, and duck-carving exhibitions.

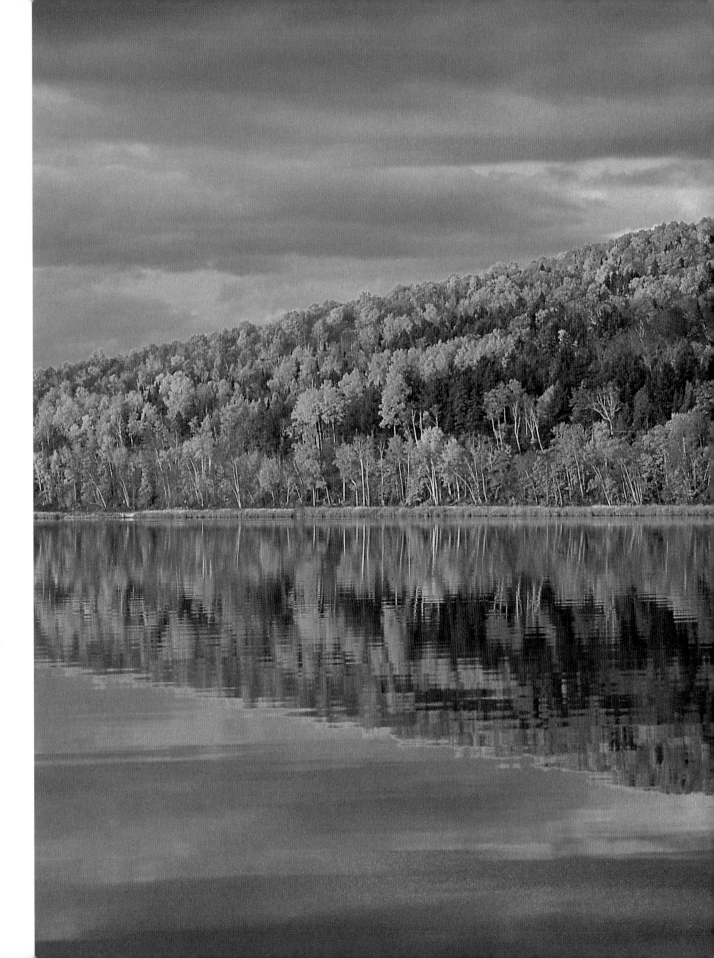

Sieur de Monts and Samuel de Champlain are thought to be the first Europeans to discover the St. John River. They sailed into the mouth of the river on June 24, 1604, the Feast of Saint John the Baptist.

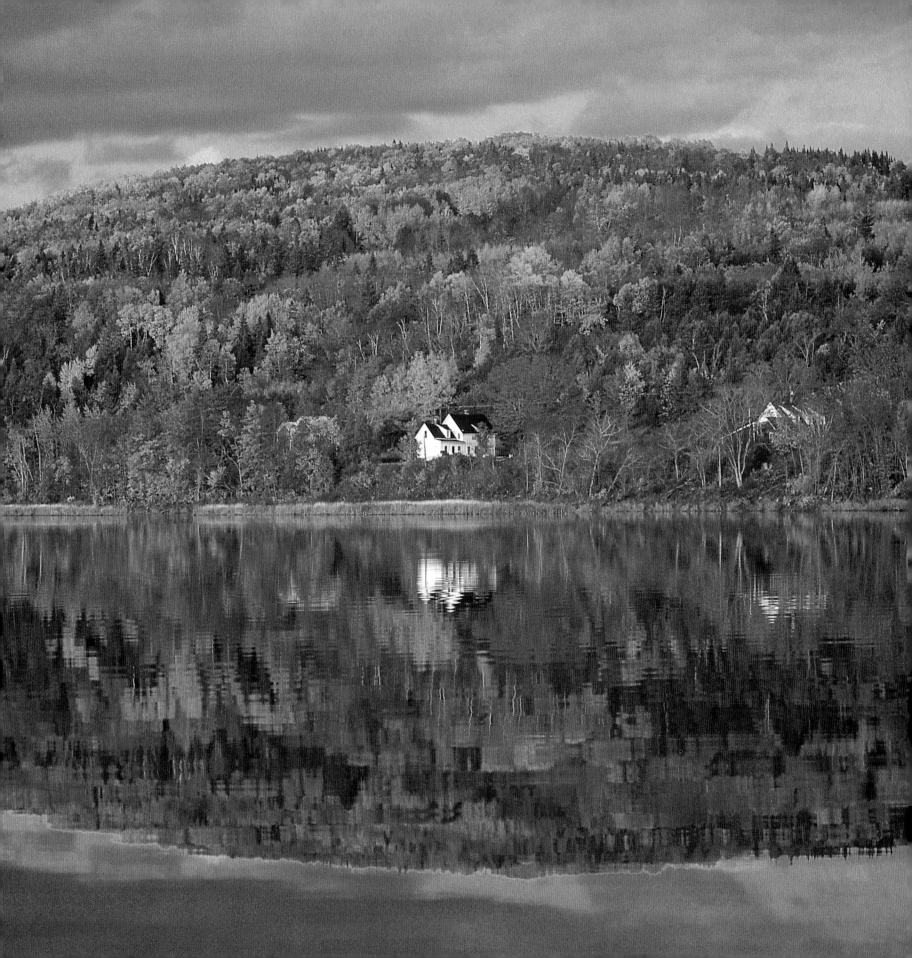

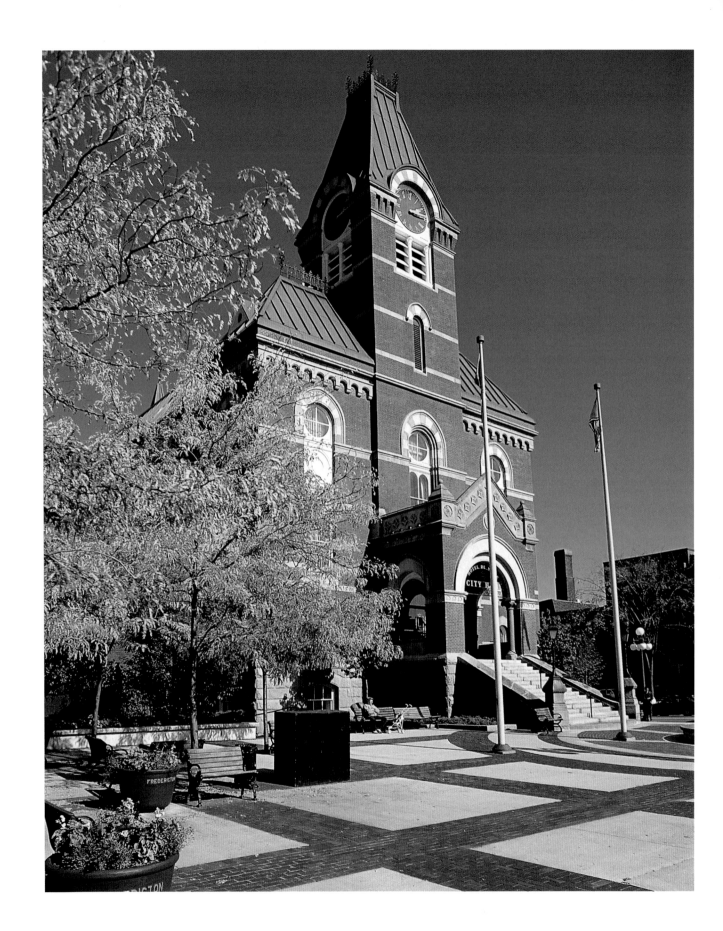

When Fredericton's brick City Hall was built in 1876, it included offices, council chambers, an opera house, a market, and a jail.

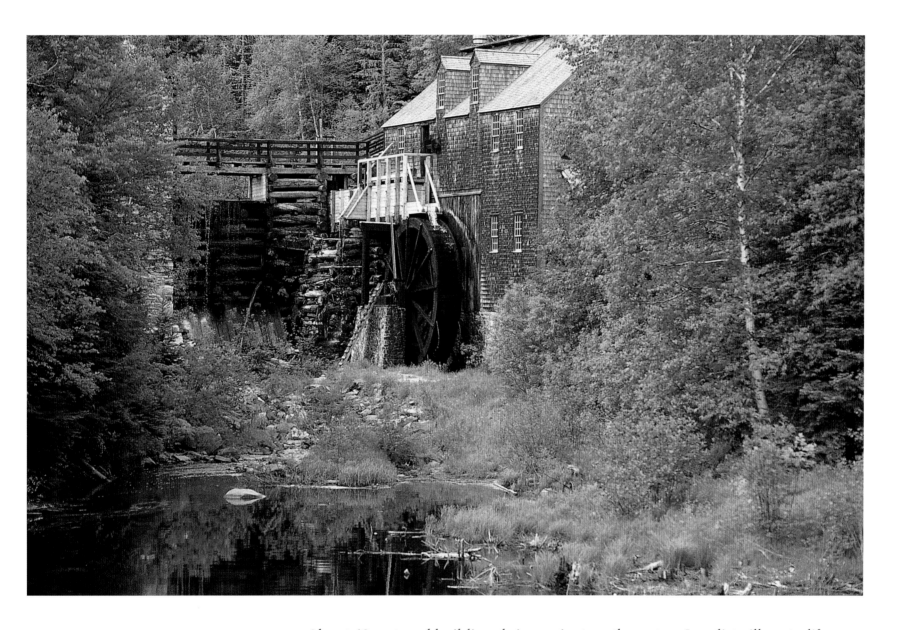

About 60 restored buildings bring a nineteenth-century Loyalist village to life at King's Landing. Costumed staff on the 121-hectare site perform the daily tasks of area settlers, including forging, weaving, and farming.

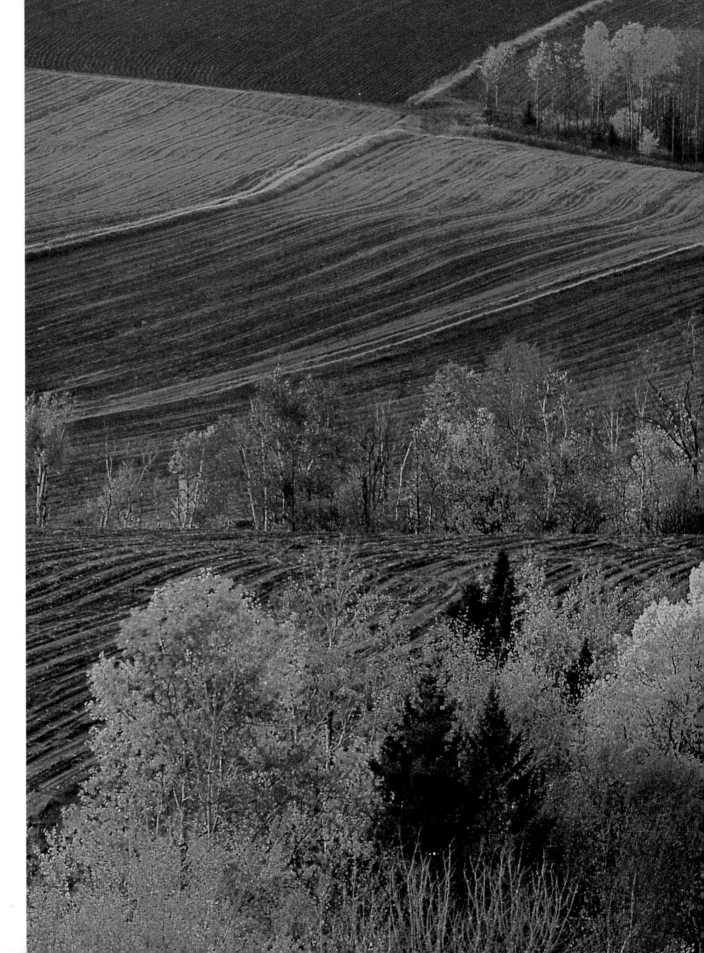

Many of the farmers around New Denmark are the descendants of the original Danish residents. Founders' Day, held each year on June 19, commemorates the struggles of the first settlers.

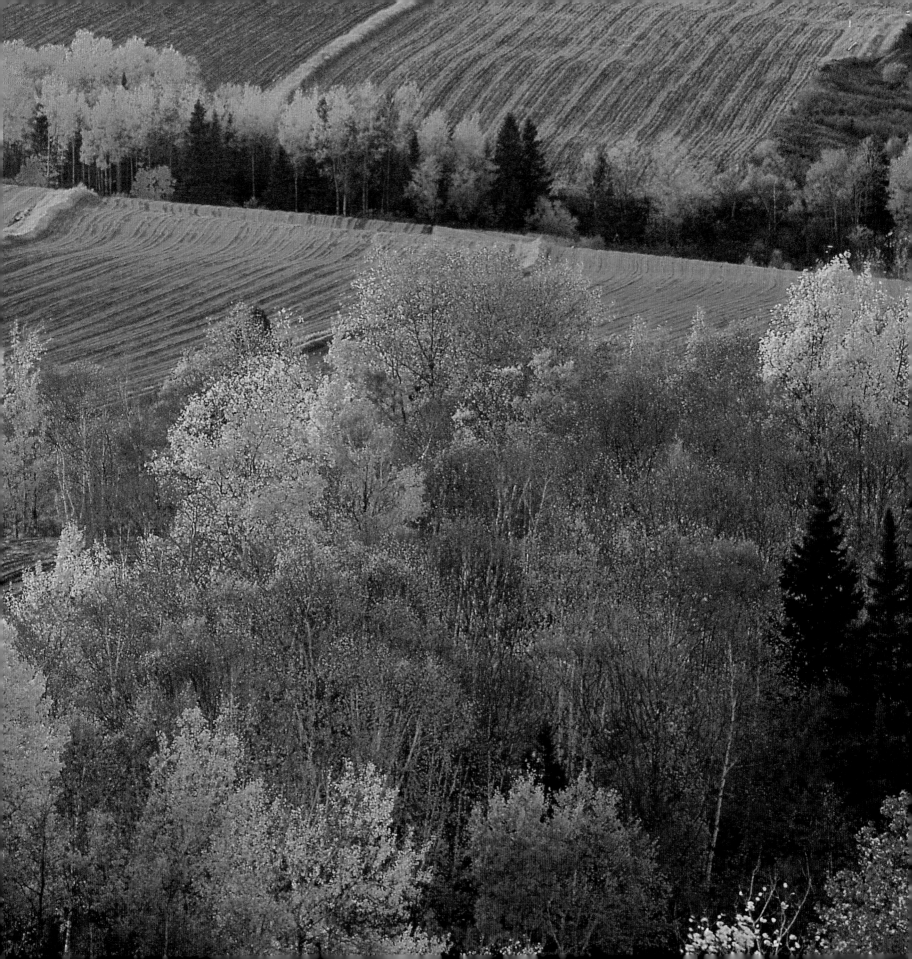

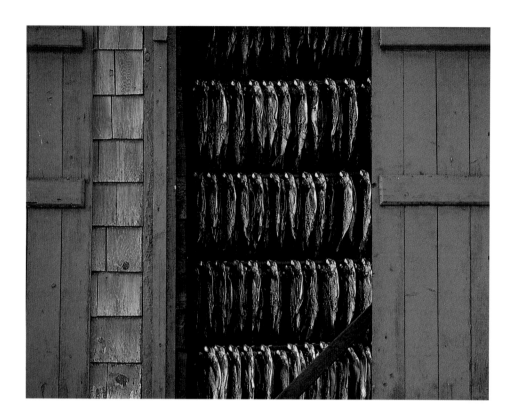

Most of Nova Scotia's herring catch is sold to packing plants in Canada and the United States, but a few fish find their way into local smokehouses and markets.

In 1872, the British government offered Danish settlers pristine farmland around New Denmark. When they arrived, the settlers found themselves on forested and rocky soil, caught between French-speaking settlers to the north and English-speaking to the south.

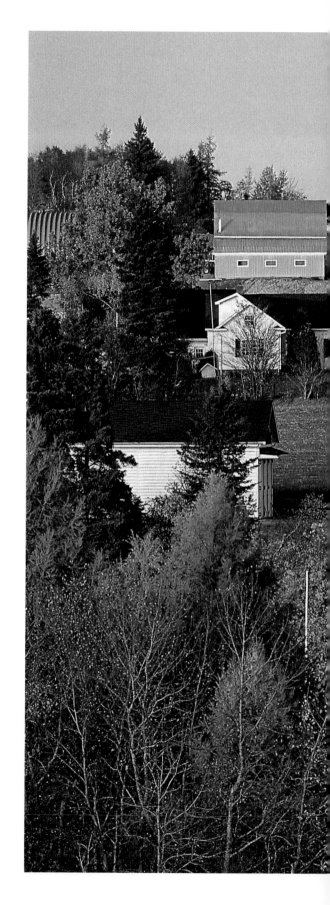

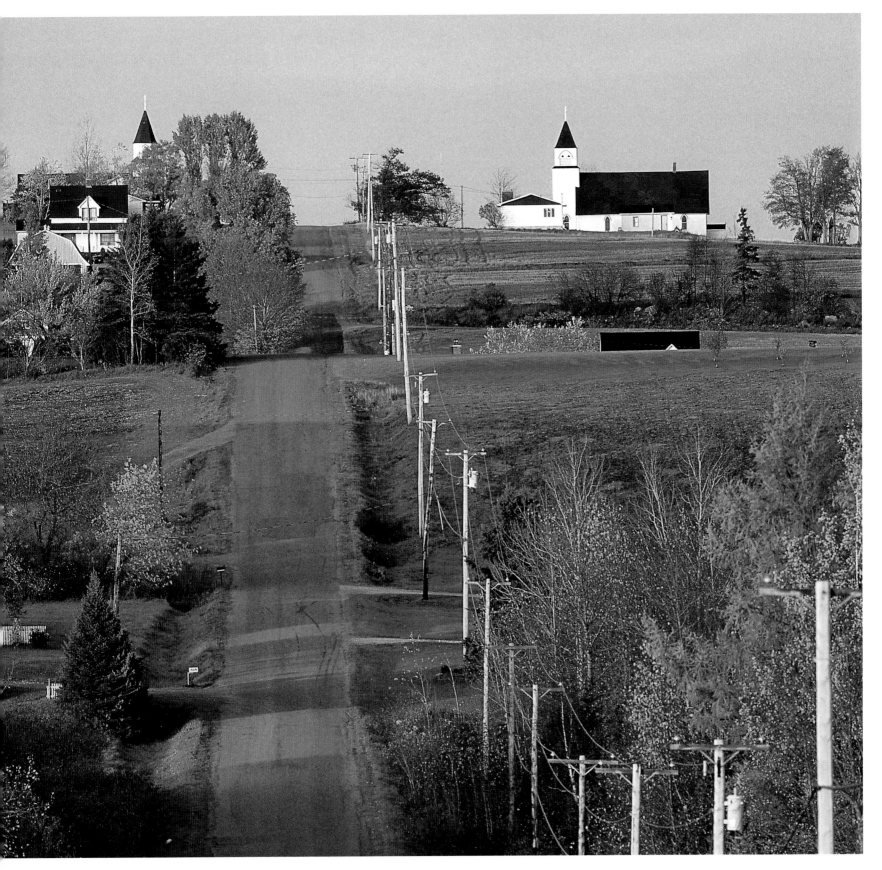

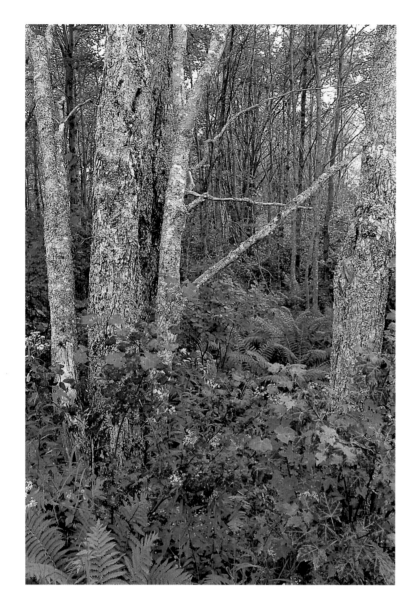

Cycling, hiking, and canoeing routes in Kouchibouguac National Park take visitors through a widely varied terrain that includes woods, marshes, and sandy ocean beaches.

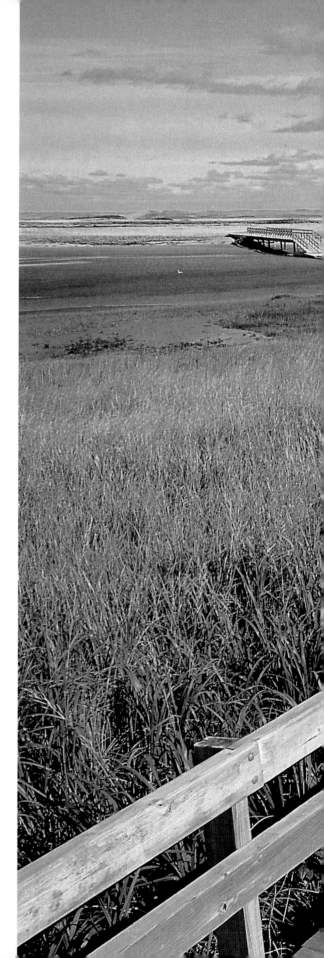

A boardwalk meanders through the salt-water marshes at Kouchibouguac National Park. *Kouchibouguac* is a Micmac word meaning "river of the long tides."

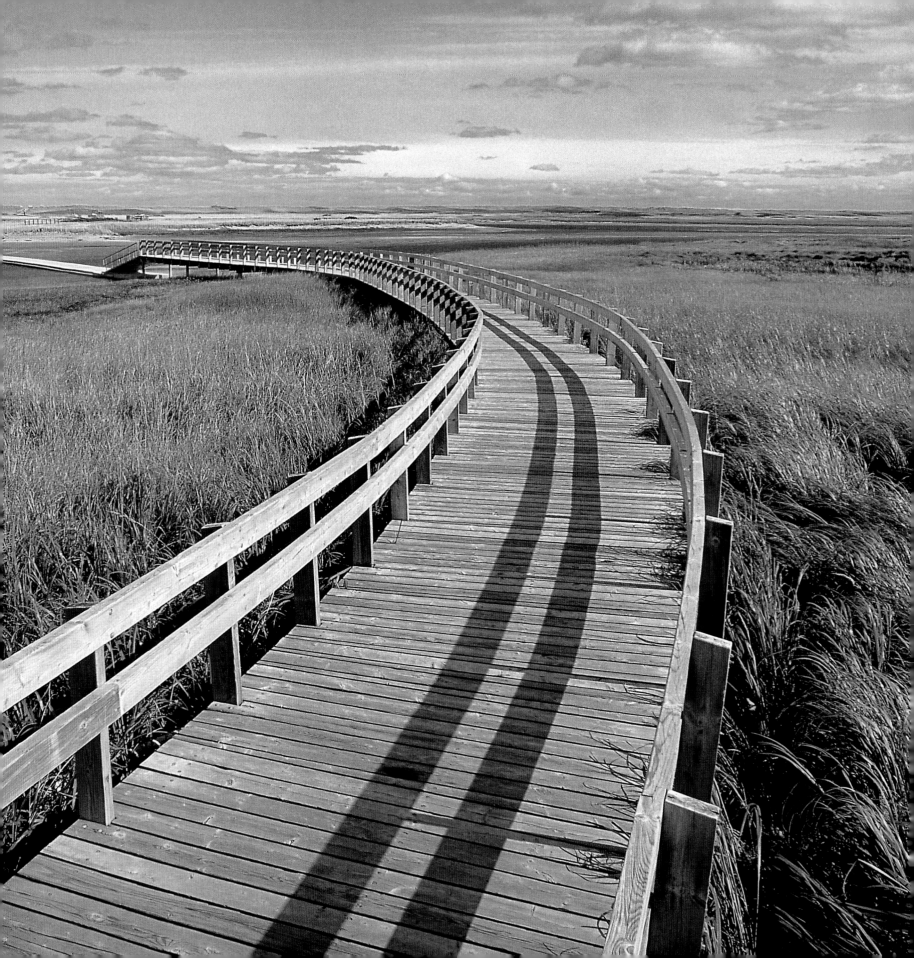

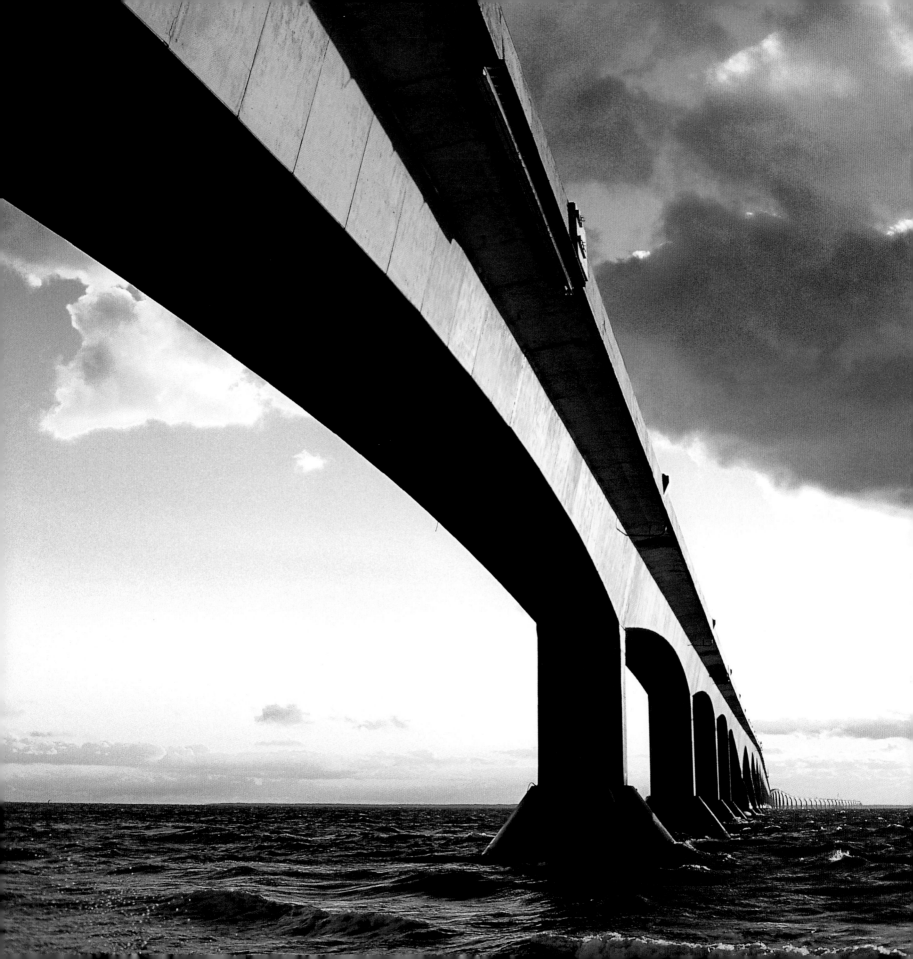

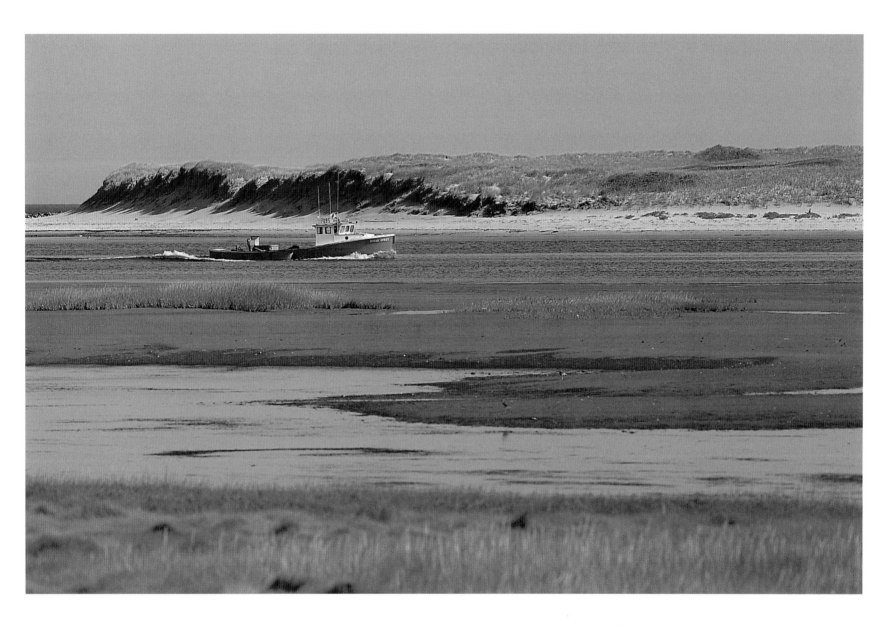

Fishing boats off the island's coast harvest tuna, herring, clams, oysters, scallops, and of course, the lobster for which the local cuisine is famous.

Confederation Bridge stretches 13 kilometres from New Brunswick to Prince Edward Island. The decision to build it was highly controversial, pitting environmentalists against businesses and travellers in favour of the bridge's convenience.

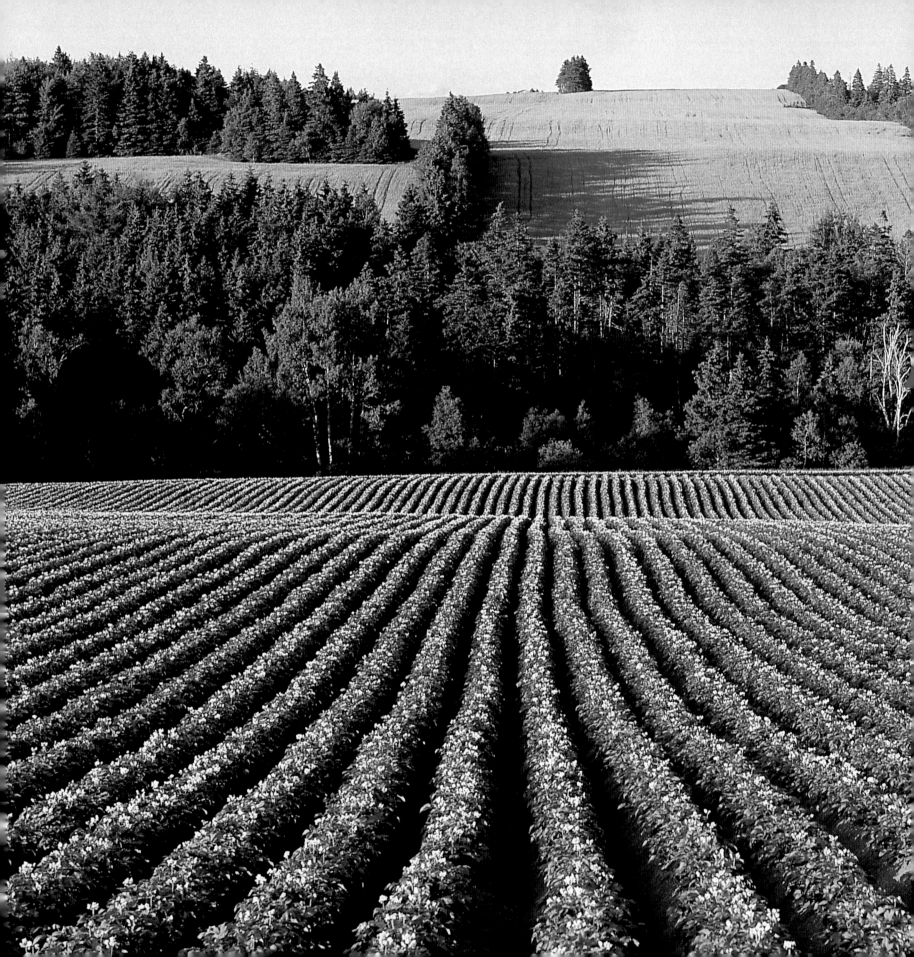

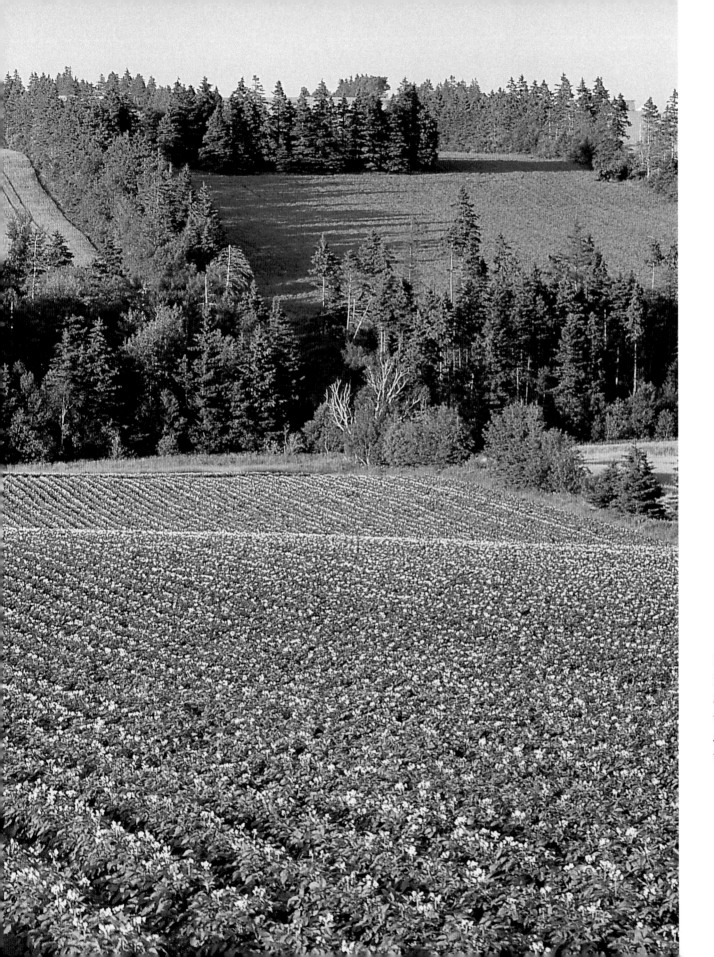

Potatoes are the island's largest agricultural crop, and the harvest is sold in grocery stores across the country.

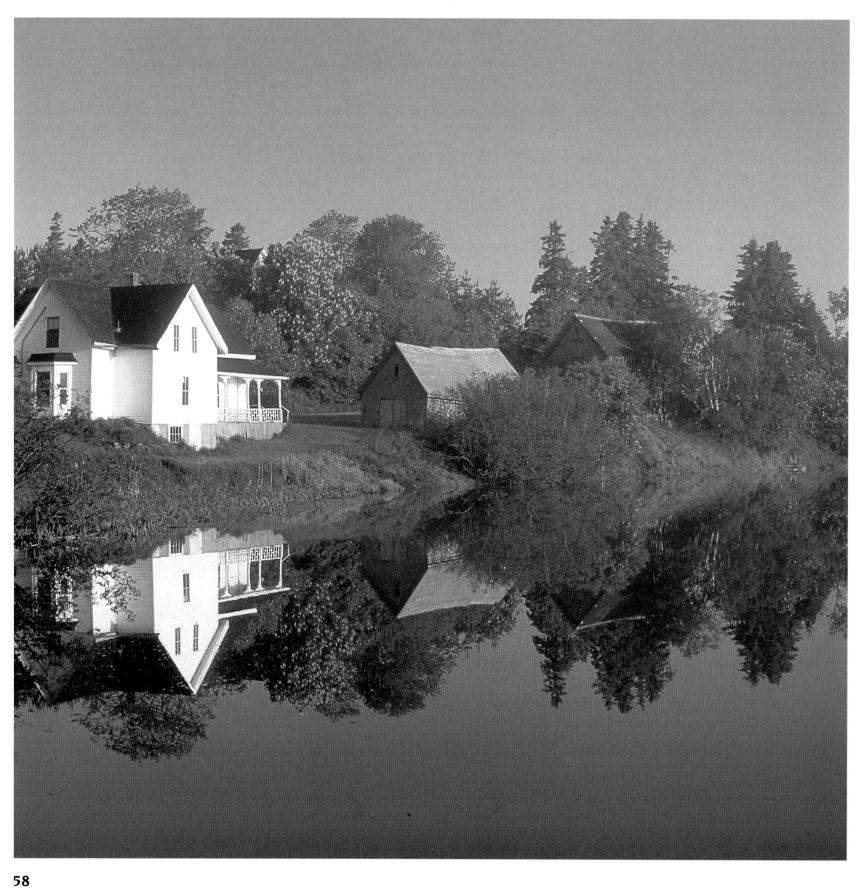

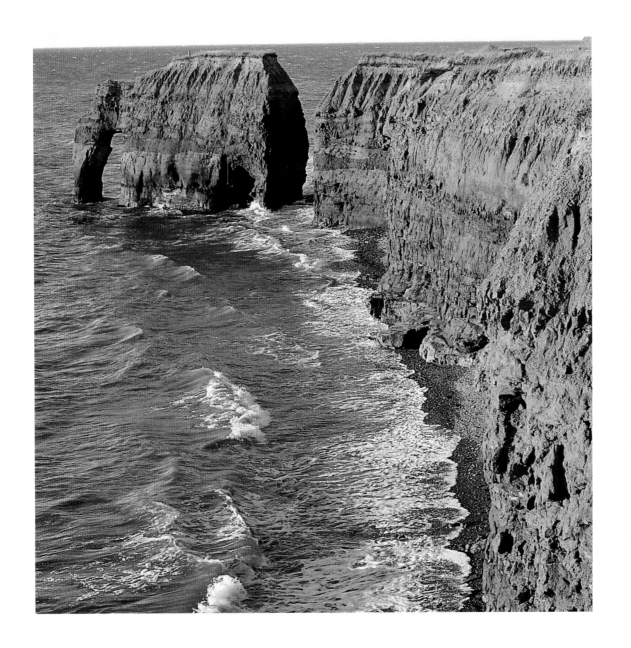

High iron content gives Elephant Rock and the surrounding cliffs their colour. The locals have reinforced the bottom of the elephant's trunk to protect the unique formation from erosion by waves.

FACING PAGE – Early morning mist rises off the Wheatley River in an idyllic scene typical of Prince Edward Island.

59

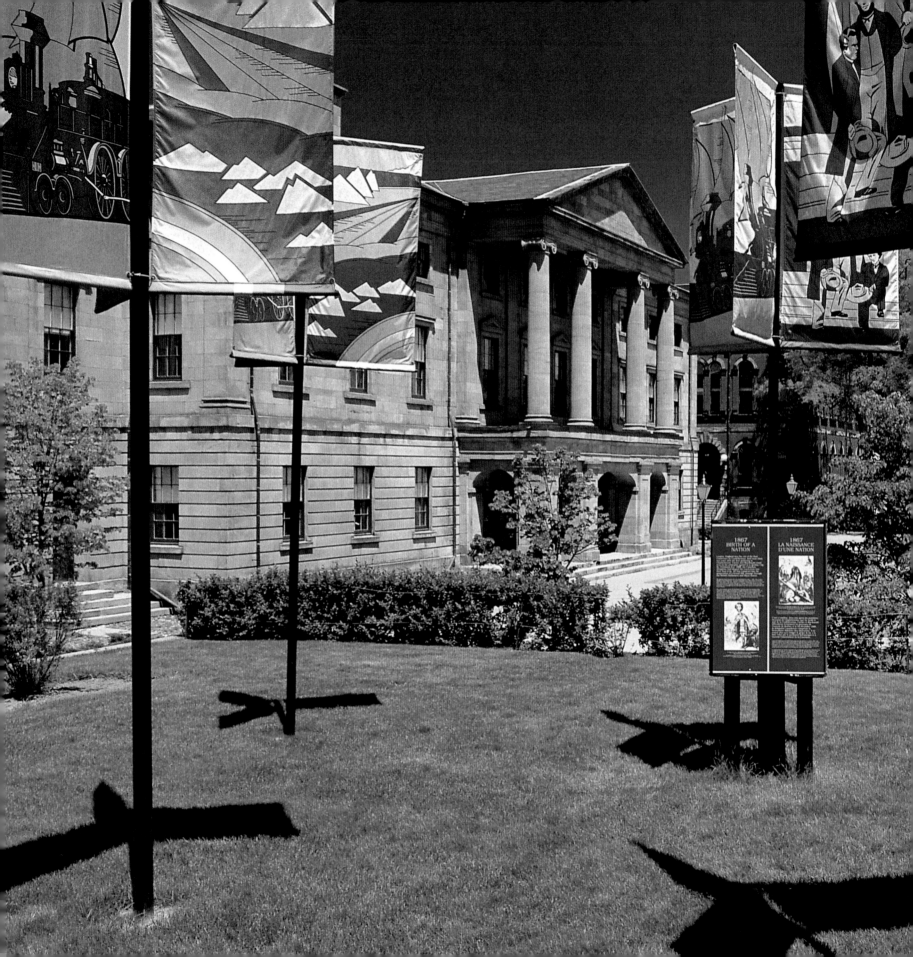

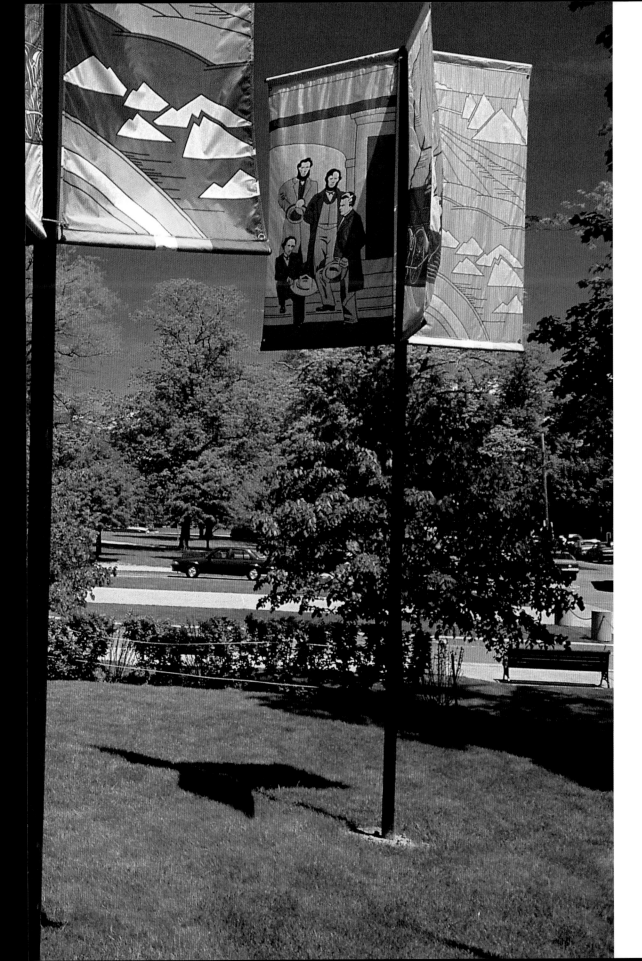

The provincial Legislature, known as Province House, was opened in 1847. This is the birthplace of Confederation, where the leaders of nineteenth-century British North America met in 1864 to discuss a possible union.

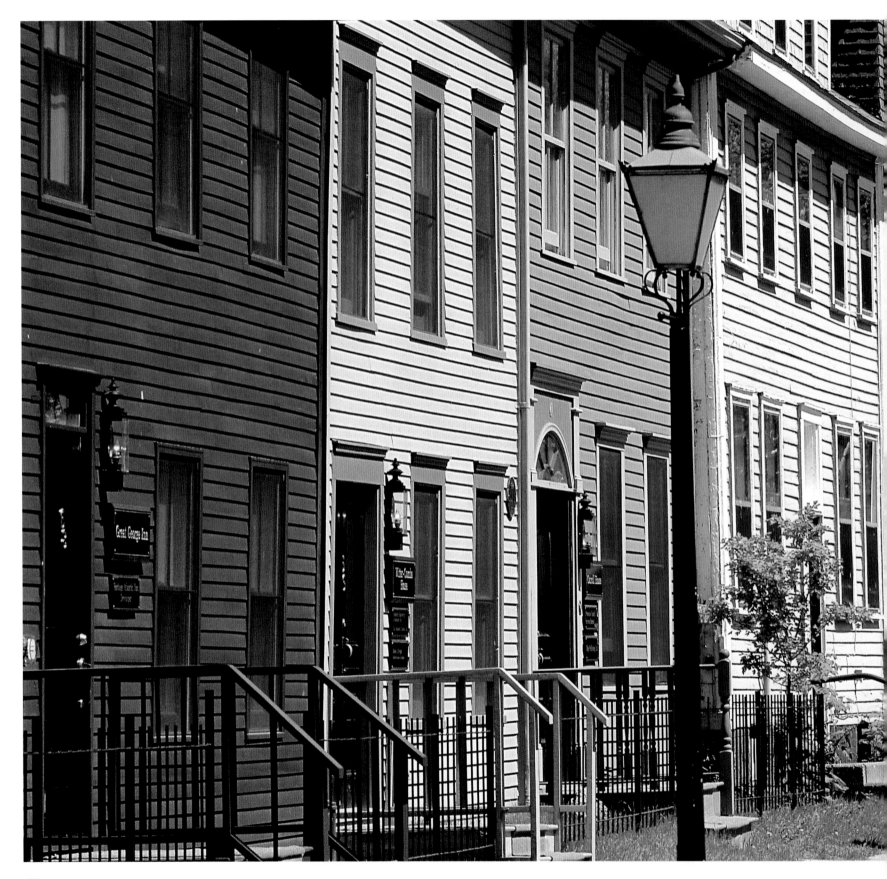

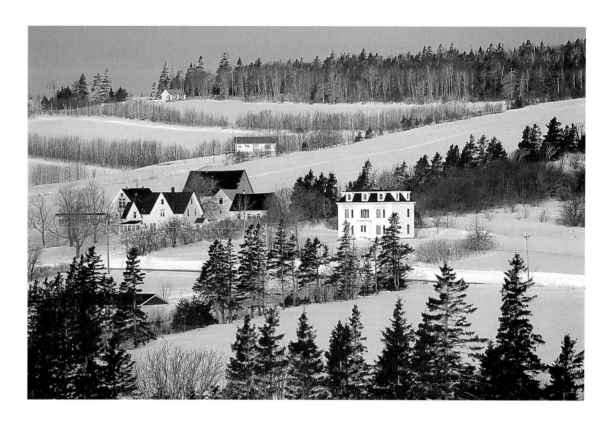

In the midst of a New Glasgow winter, it's hard to guess that the town is known for its lush berry and fruit crops, made into famous jams and jellies by the P.E.I. Preserves Company.

When the Fathers of Confederation arrived in Charlottetown, they walked from Prince Street Wharf up Great George Street to Province House. In honour of their achievements, the route has been designated a National Historic Site.

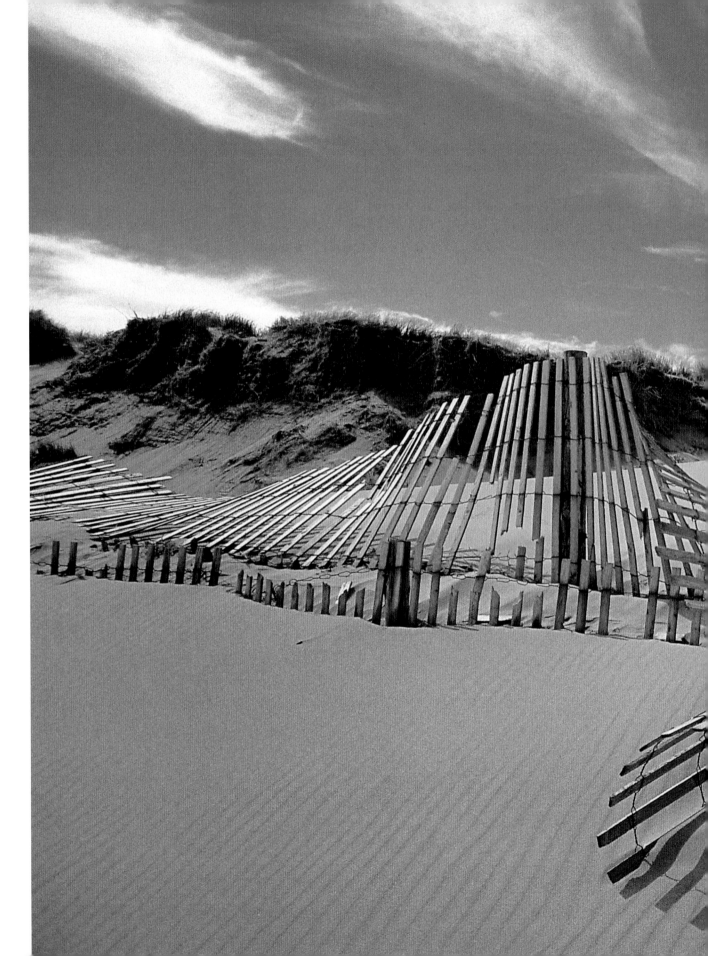

Along the Gulf of
St. Lawrence, Prince
Edward Island
National Park protects
about 40 kilometres of
cliffs and beaches.
The waters lure
crowds of summer
swimmers, while
skiers and snowshoers
enjoy the park in
winter.

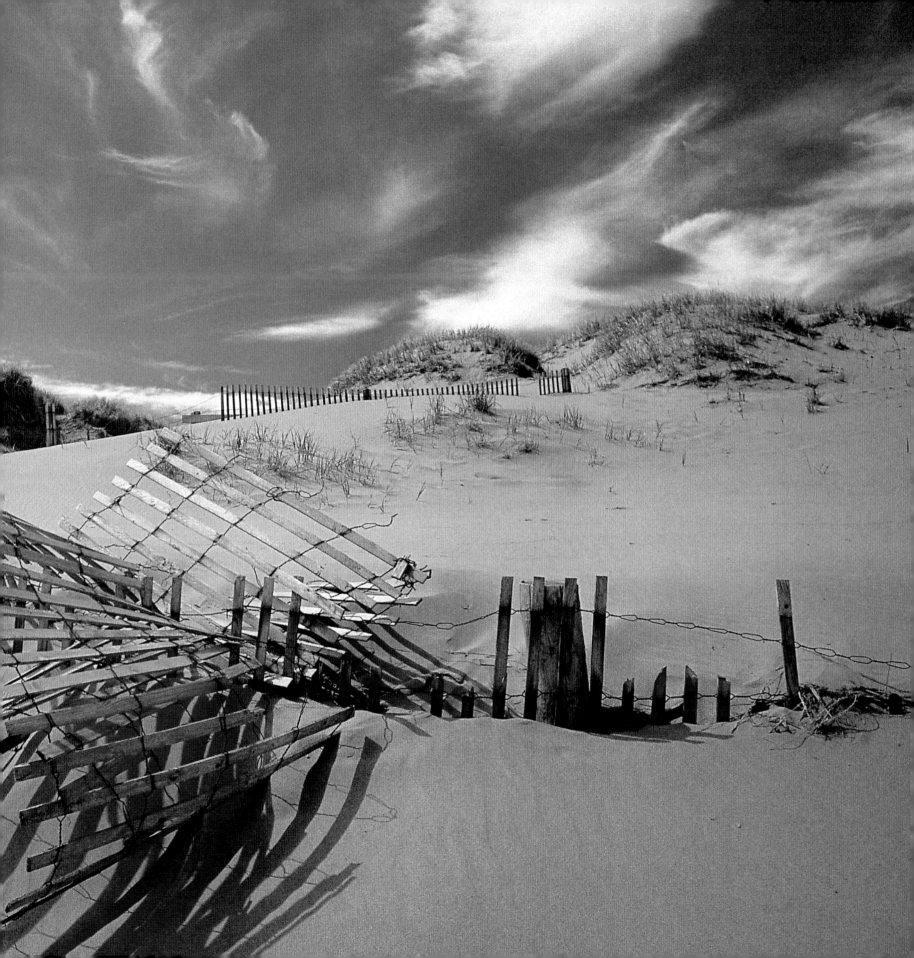

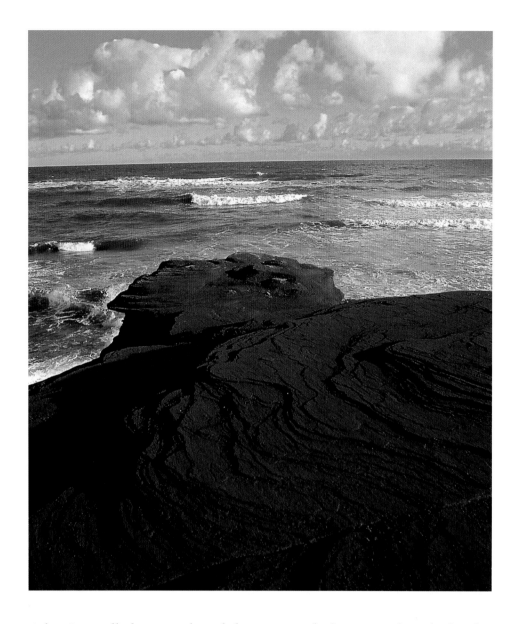

Atlantic swells have sculpted the west end of Prince Edward Island National Park to create jagged red sandstone cliffs and arresting rock formations.

There are more than 2000 farms on the island, producing crops that range from tomatoes to strawberries.

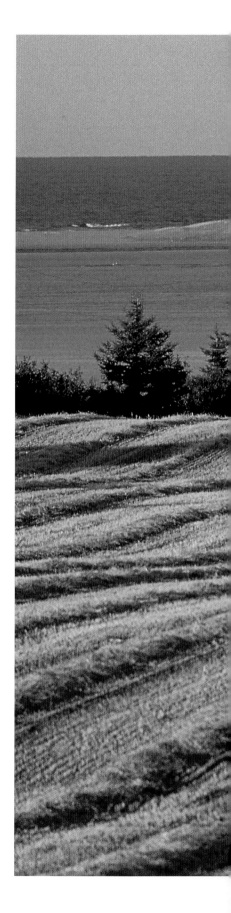

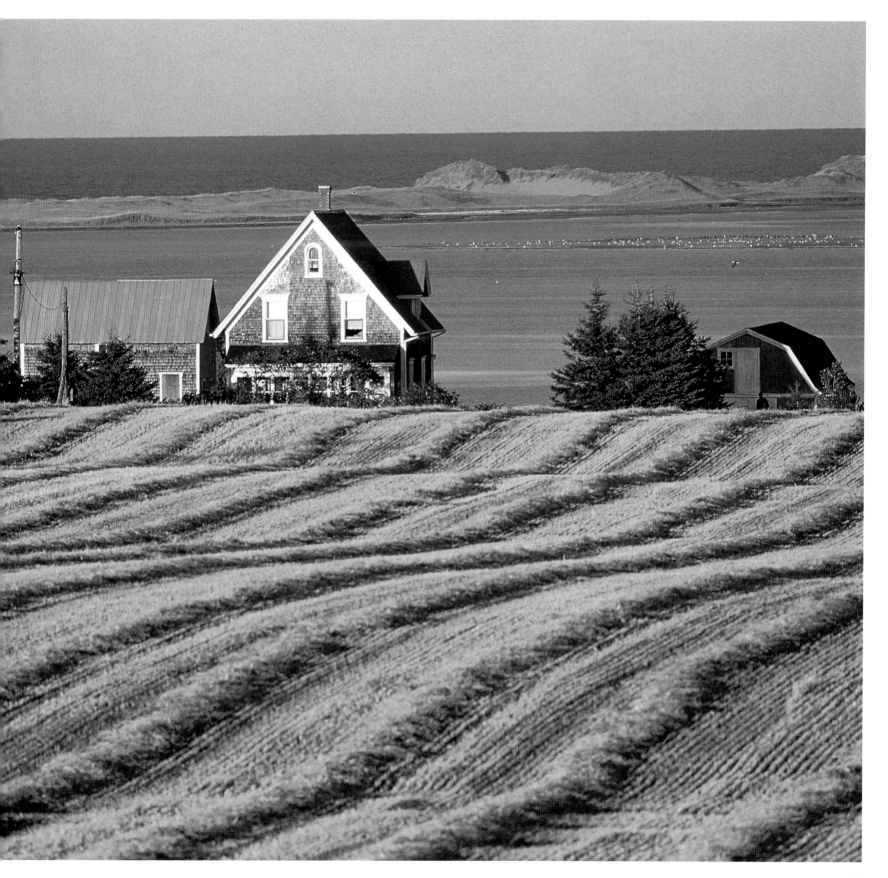

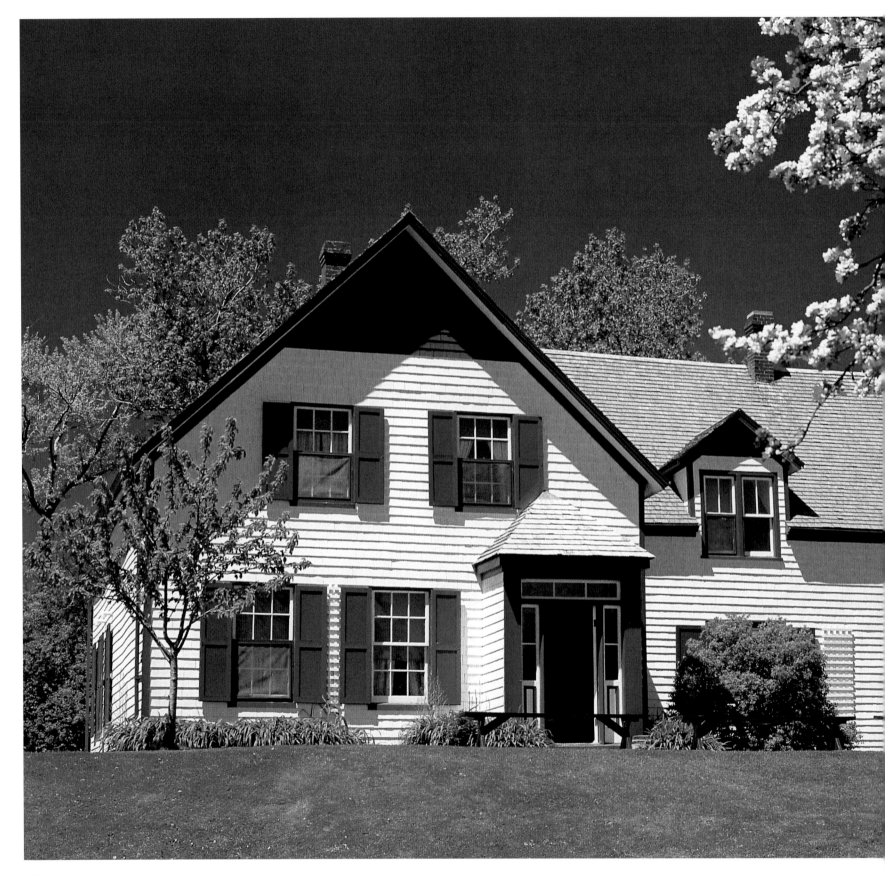

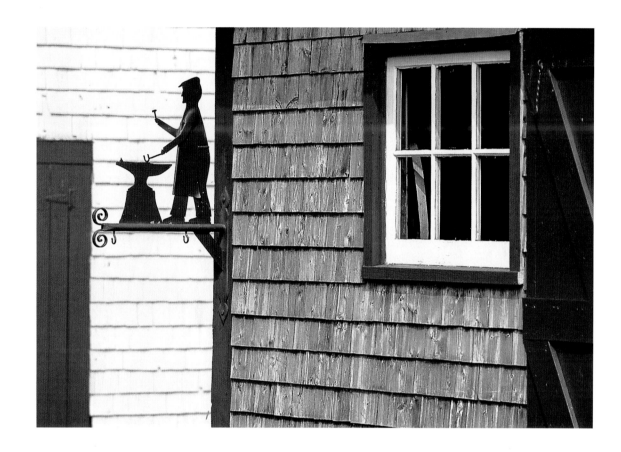

Orwell Corner Historic Village re-creates nineteenth-century Prince Edward Island with a working farm, operated in the style of the early settlers. This wrought-iron sign marks the local blacksmith's shop.

Green Gables House in Cavendish was the setting for L. M. Montgomery's *Anne of Green Gables*, a novel inspired by the author's own experiences as an orphan. Since it was published in 1908, the novel has been translated into about 20 languages, and read by millions of children and adults around the world.

About 225 kilometres long, Prince Edward Island is Canada's smallest province. Fishing and agriculture combine with tourism to support the island's economy, and many summer visitors find rooms for rent in picturesque farmhouses and cottages.

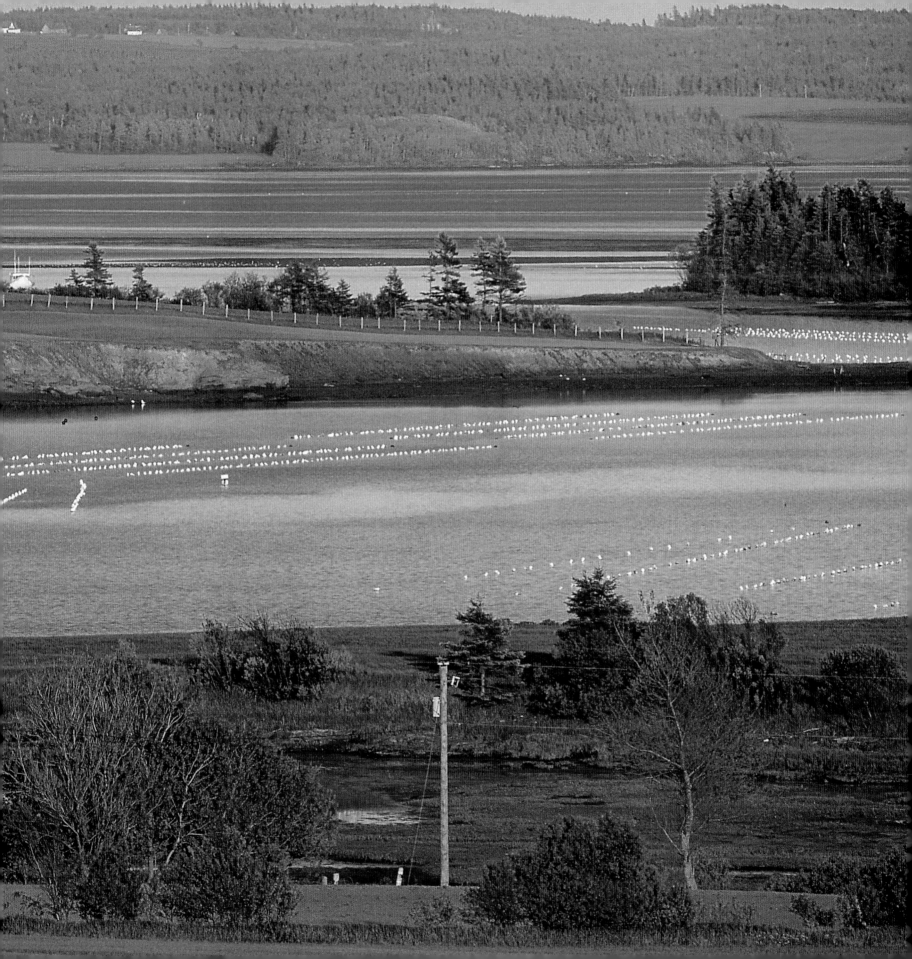

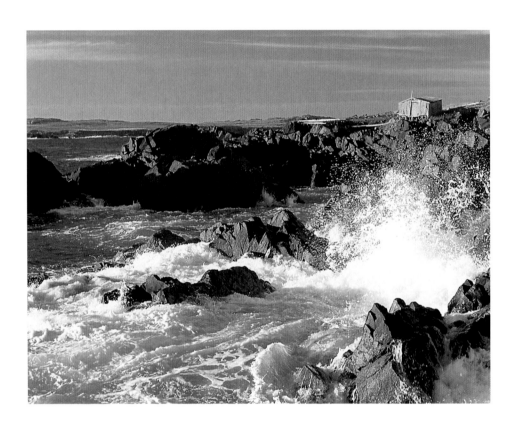

It's not the most hospitable shore, but it was a welcome sight to John Cabot and his crew. Cape Bonavista, Newfoundland, was the first land seen by Cabot when he reached North America on June 24, 1497.

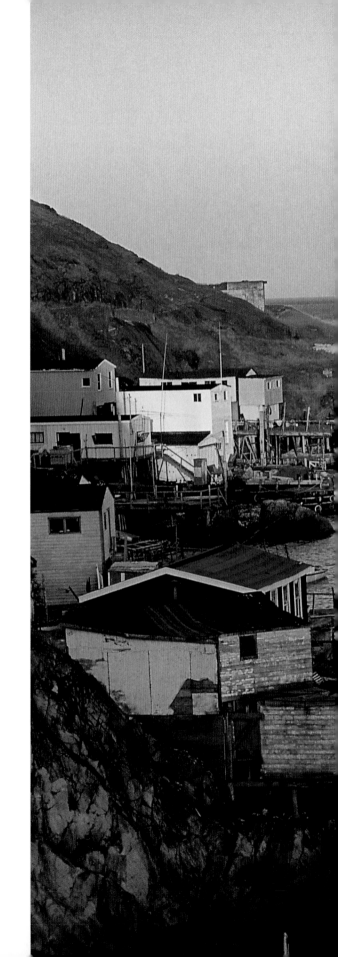

The entrance to St. John's harbour is known as The Narrows. The harbour has a long and turbulent history. It was first discovered by Cabot, and named Rio de San Johem by Portuguese explorer Gaspar Côrte-Real in 1500. Later, the Dutch, the French, and the English fought for control of the area.

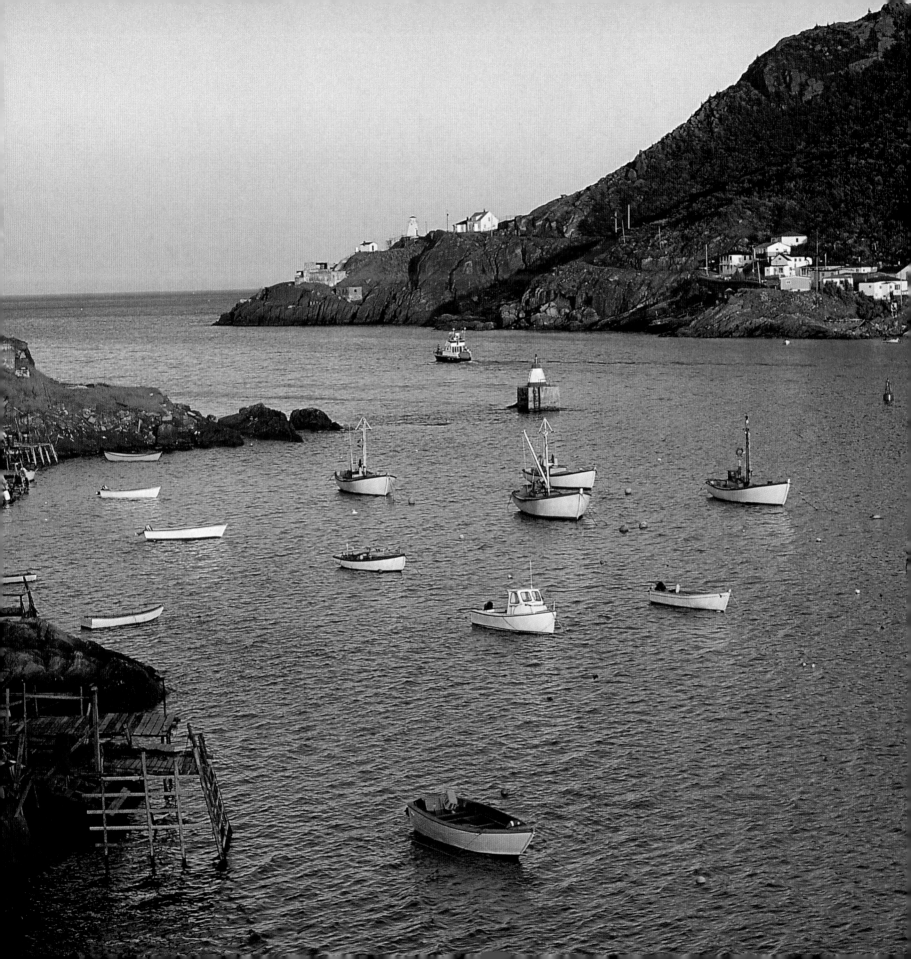

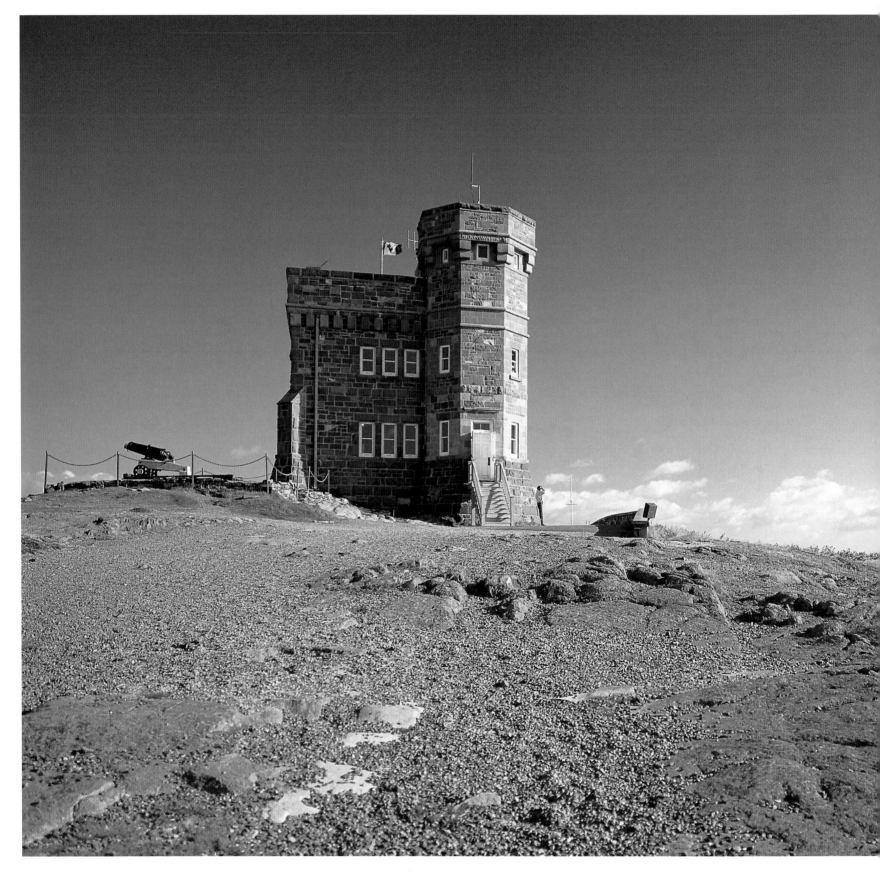

In 1901, the world's first radio transmission was sent from Cornwall, England. Italian inventor Guglielmo Marconi received the message in Morse code at Signal Hill, now a national historic site.

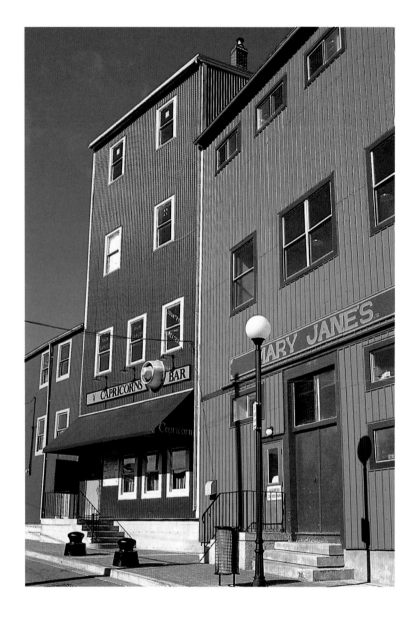

The streets of St. John's were once lined with pubs and brothels as sailors from Spain, Portugal, Holland, France, and England mingled in the port. Today, the pubs on George Street are more respectable, but still a highlight of local nightlife.

The growth of St. John's, Britain's first colonial outpost, marked the birth of the British Empire and the start of colonial expansion around the world. Newfoundland remained a British colony until 1949.

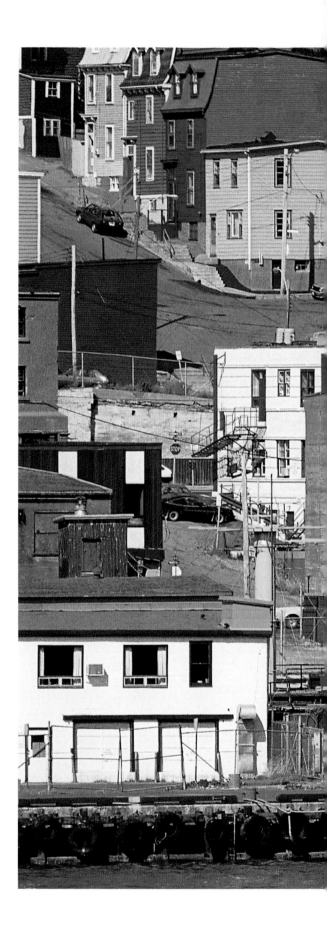

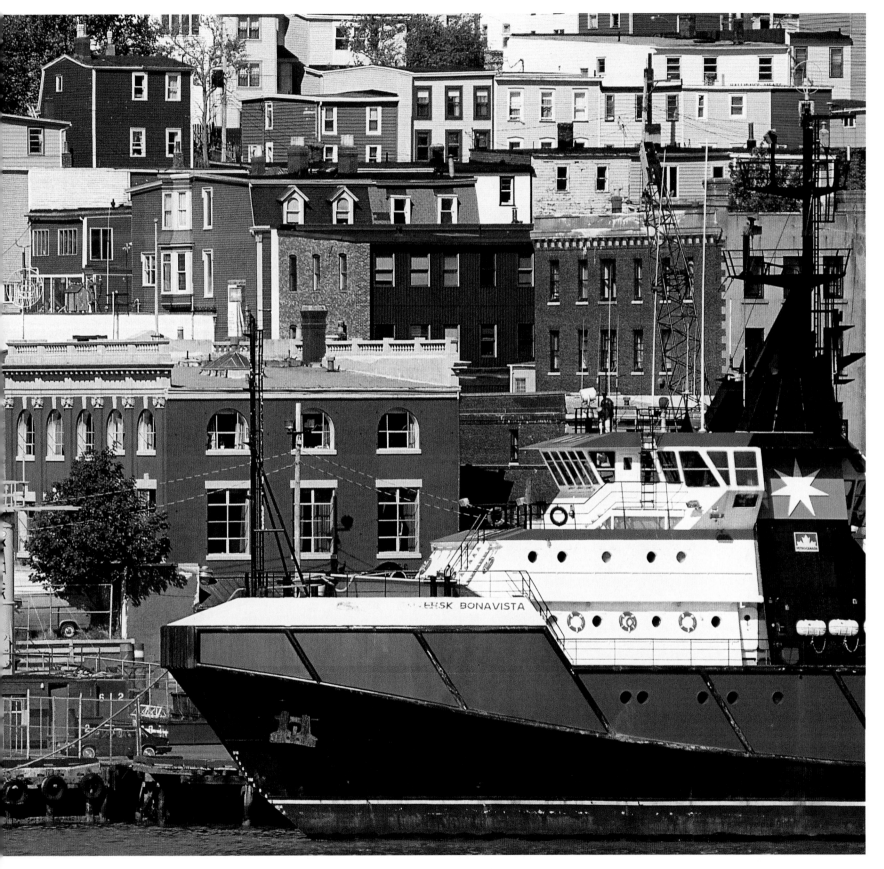

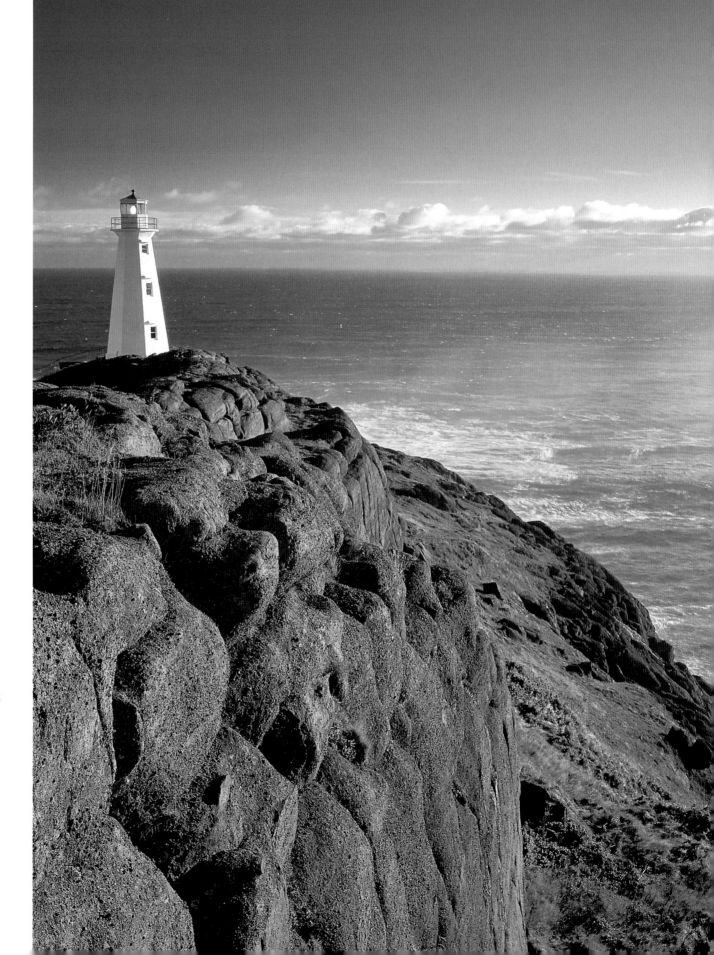

Canada's oldest lighthouse stands 75 metres above the Atlantic on Cape Spear, North America's eastern tip. The beacon was built in 1836 and used until 1955. The lighthouse keeper's quarters have now been restored.

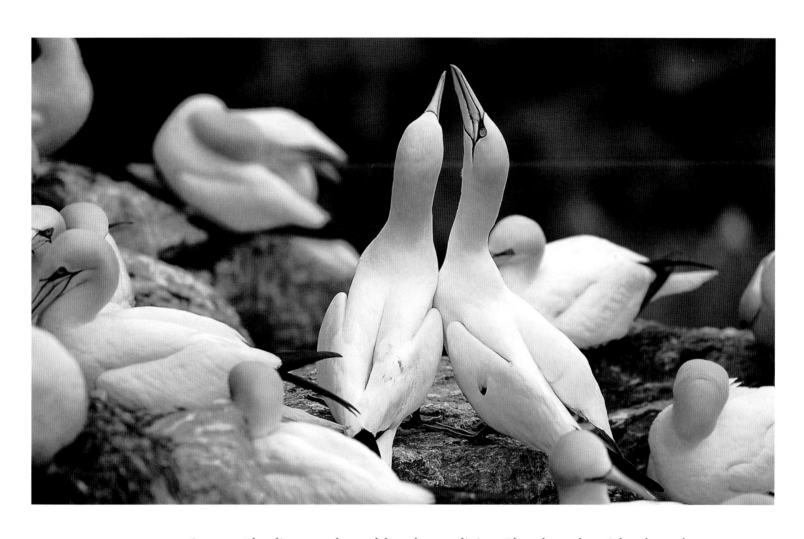

Gannets' bodies are shaped for plunge diving. They breed on islands such as Baccalieu Island, returning each year with the same mate to the same nesting site.

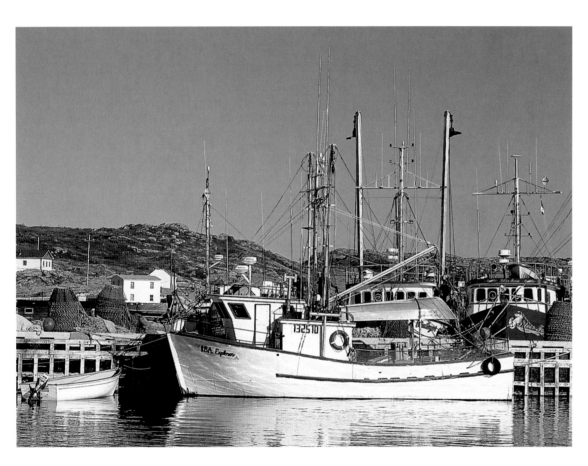

Joe Batt's Arm is just one of many unusually named
Newfoundland villages. Others include Piccadilly
Head, Nick's Nose Cove, and Heart's Content.

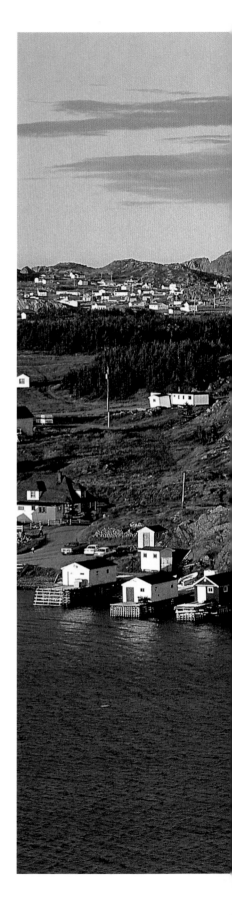

On the island's northern coast, Notre
Dame Bay is one of the province's
more highly populated areas. About
80 villages dot the shores.

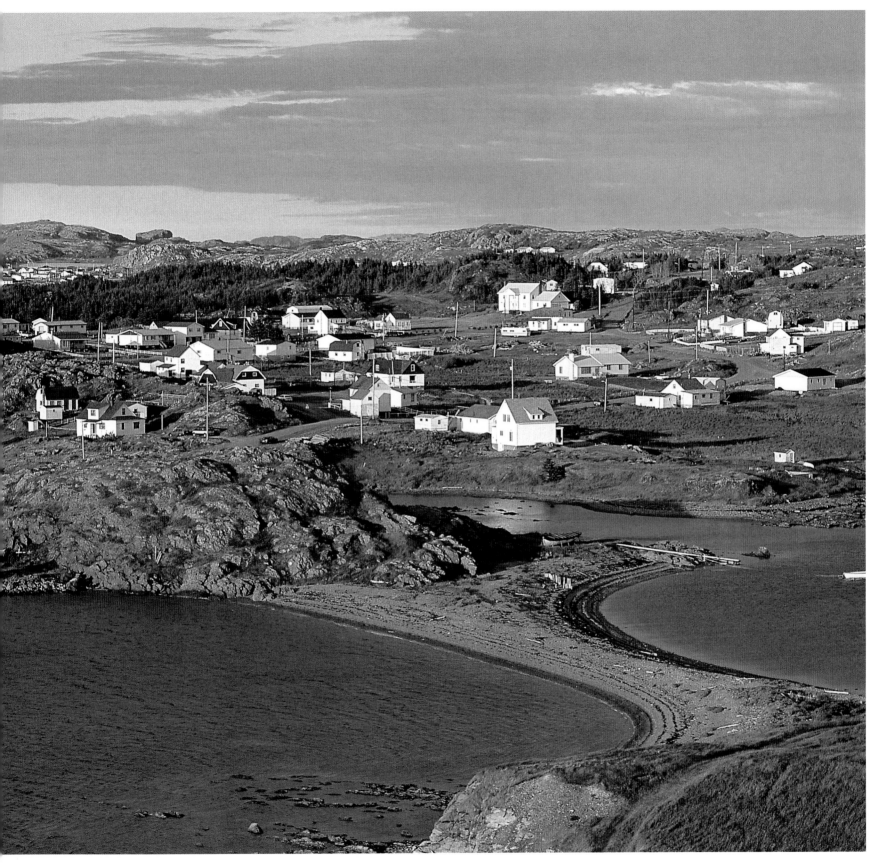

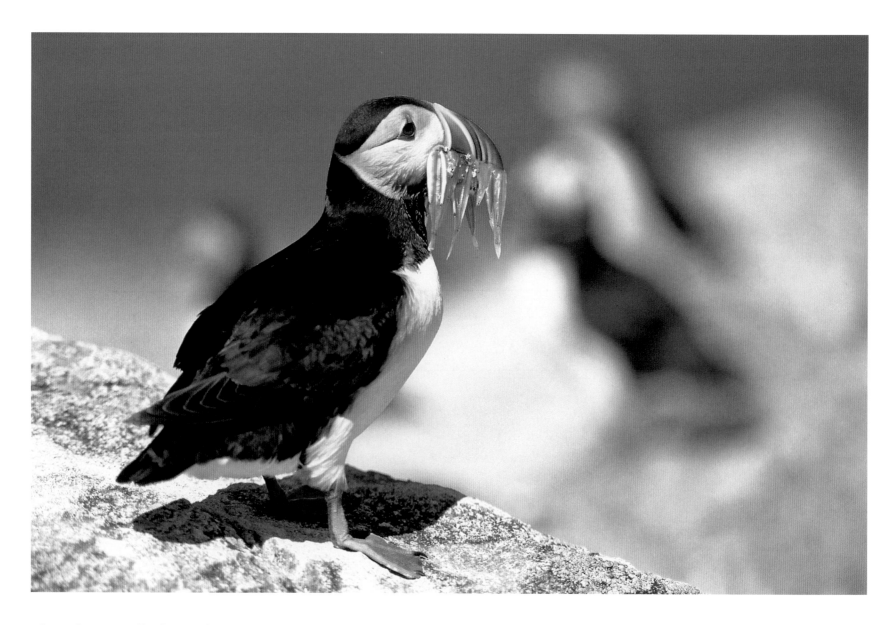

The Atlantic puffin has only one chick per year. It spends the
summers in nesting colonies and winters on the open seas.

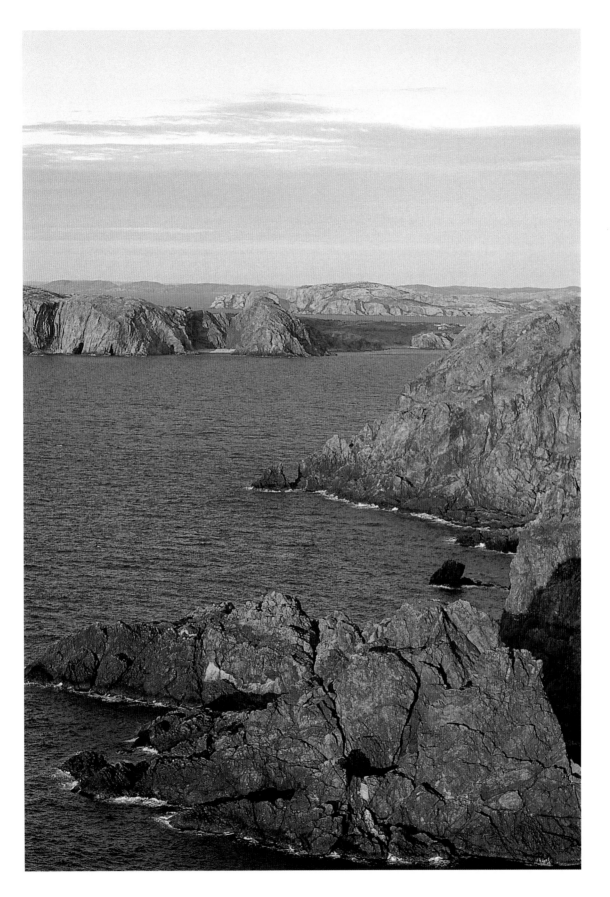

The rugged scenery near Twillingate in Notre Dame Bay makes it a favourite destination of Newfoundland visitors.

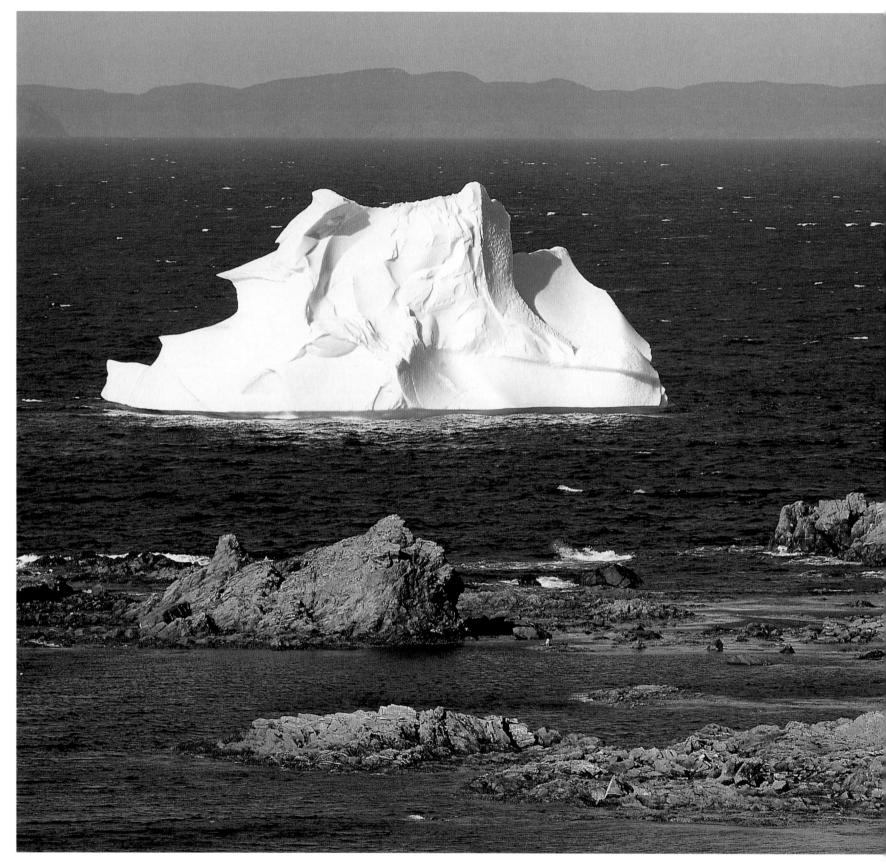

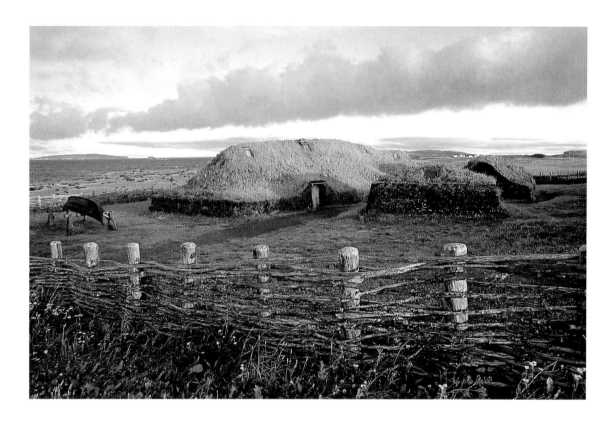

Five hundred years before Cabot sighted Newfoundland, Norse sailors and explorers founded a village at what is now designated L'Anse aux Meadows National Historic Park. Archaeologists have uncovered remains from A.D.1000 and visitors to the UNESCO World Heritage Site can wander through sod buildings and view artifacts and models of the settlement.

Icebergs from as far away as Greenland are a common sight in the waters of Notre Dame Bay.

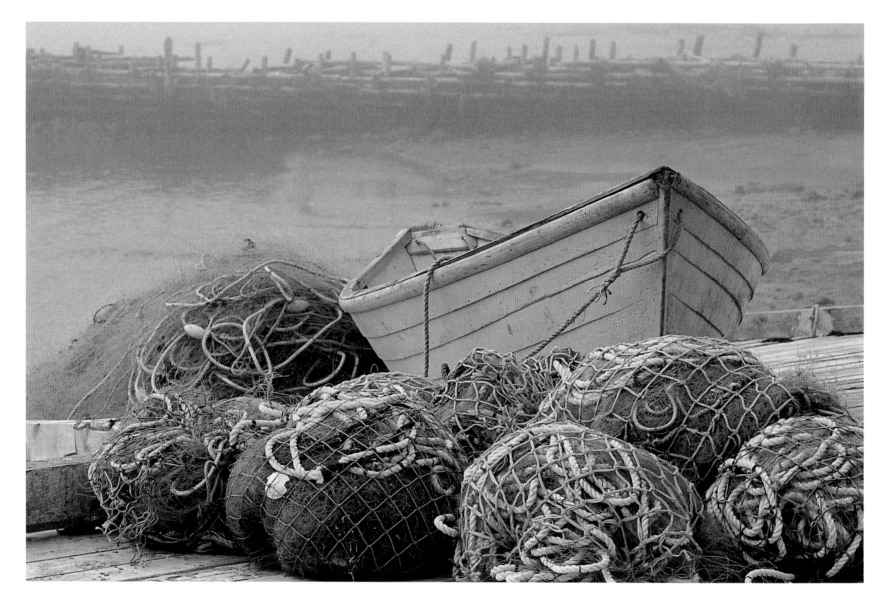

Morning mist provides a romantic backdrop for fishing nets in St. Bride's, a reminder of a way of life slowly dying out along Newfoundland's shores.

A UNESCO World Heritage Site, Gros Morne National Park encompasses stony beaches, cliffs, caves, bogs, forests, and amazing fjords. Scientists value these rocky slopes for the evidence they provide about ancient movements in the earth's crust.

Overleaf:
The spectacular fjords of Gros Morne National Park could be mistaken for those of Norway. In 15-kilometre-long Western Brook Pond, cliffs drop 700 metres into the water.

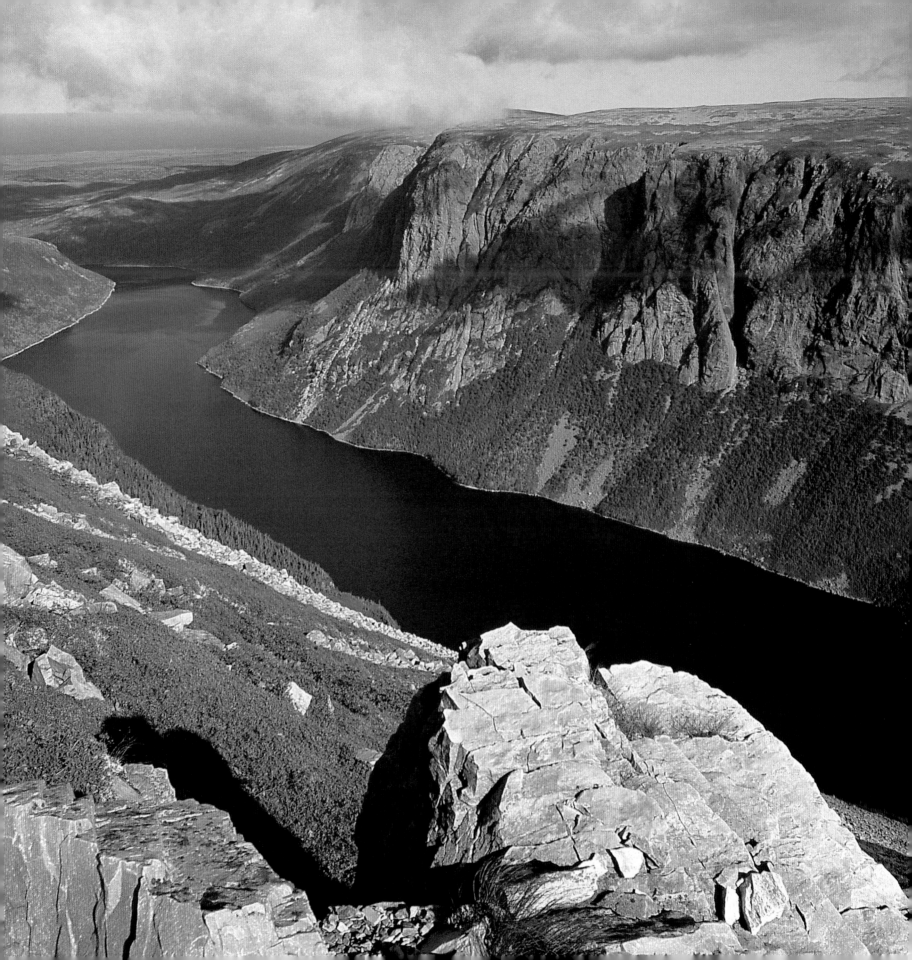

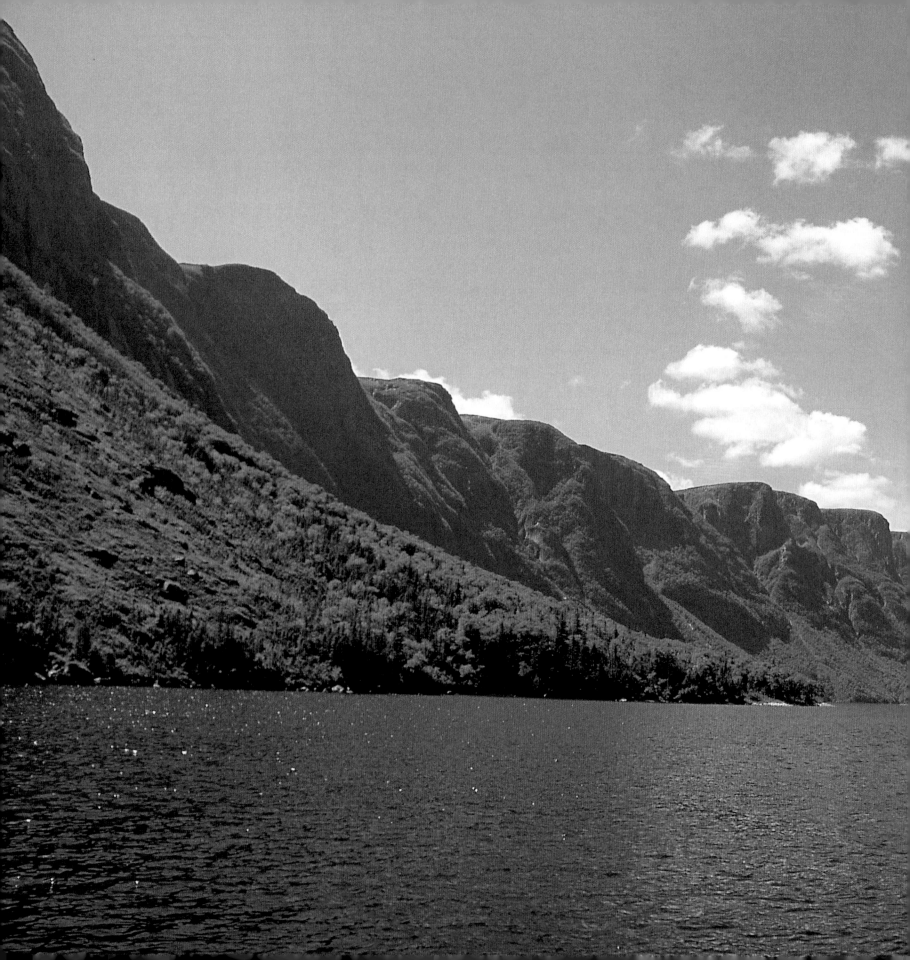

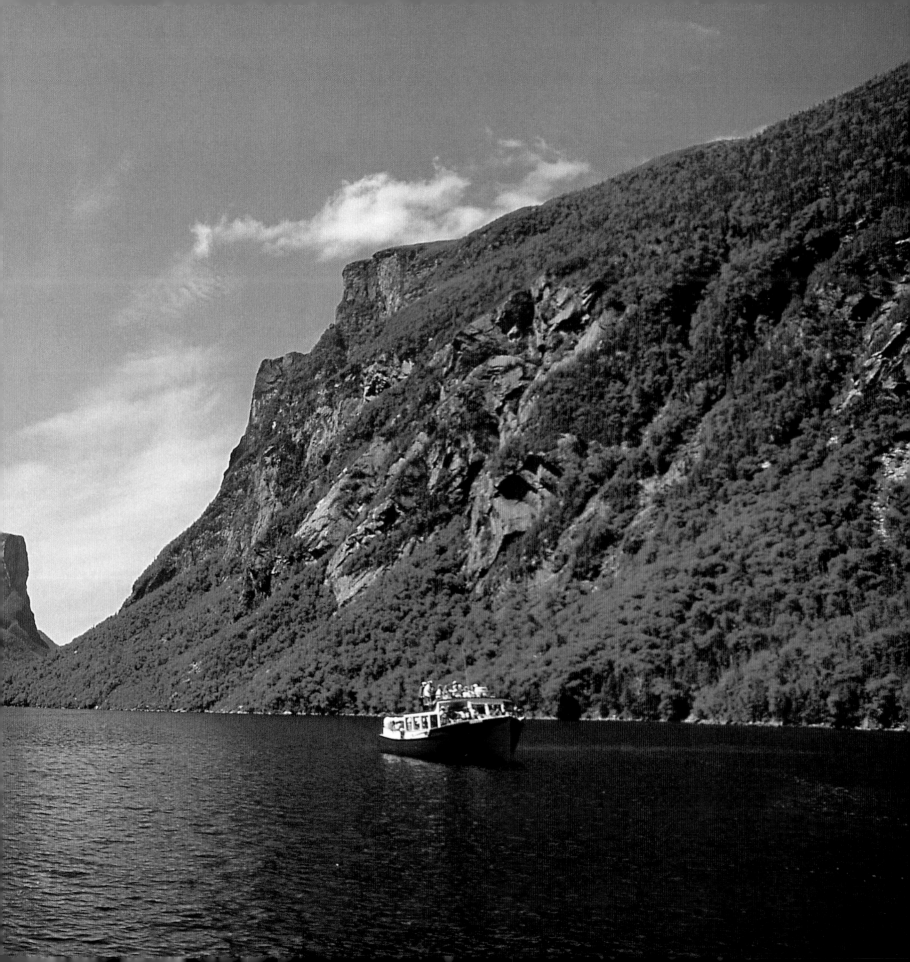

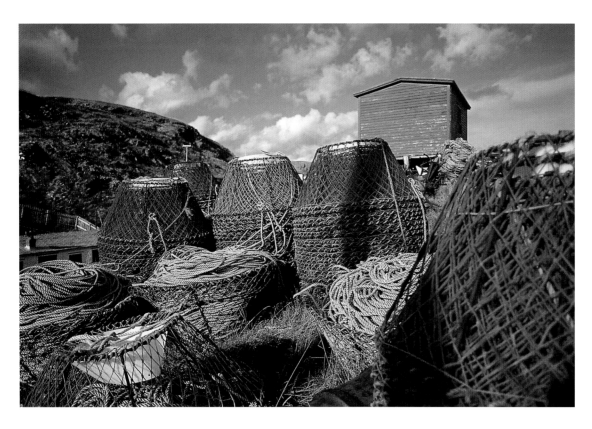

Fishing villages surround Conception Bay, just east of St. John's. The area was named by early Portuguese explorers in honour of the Virgin Mary.

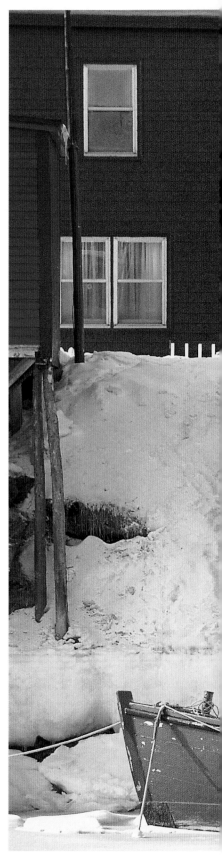

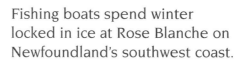

Fishing boats spend winter locked in ice at Rose Blanche on Newfoundland's southwest coast.

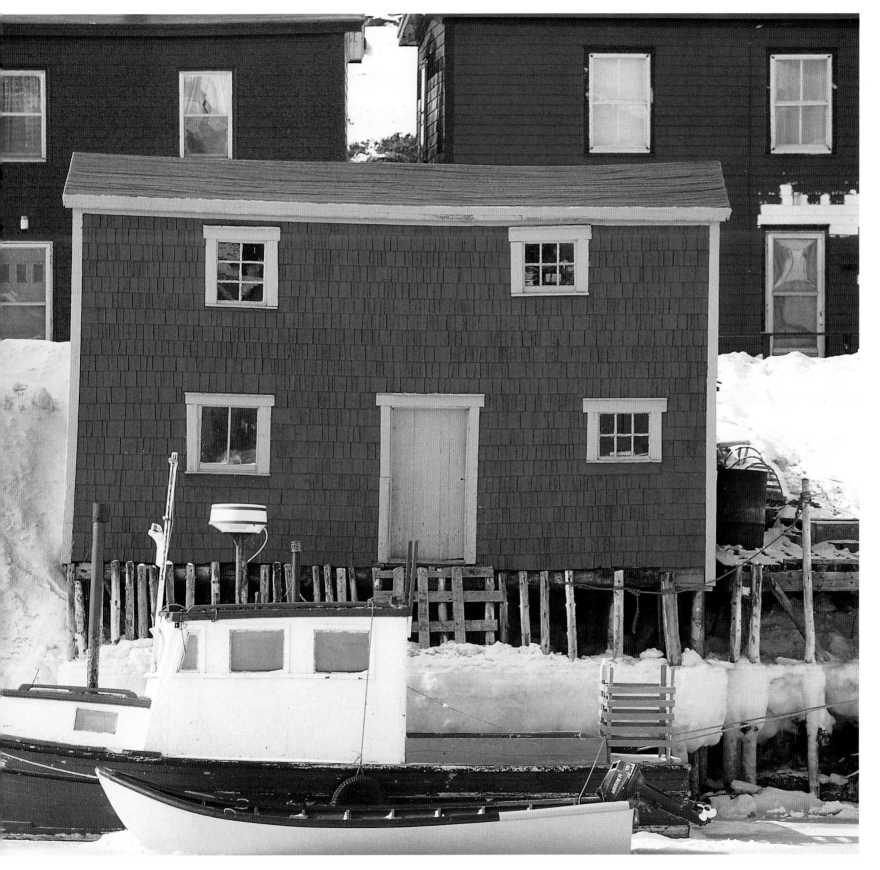

Terra Nova National Park offers a wilderness haven for bears, lynx, moose, beavers, bald eagles, and nature-seeking city dwellers. More than 100 kilometres of hiking trails wind through the park and along the fjords.

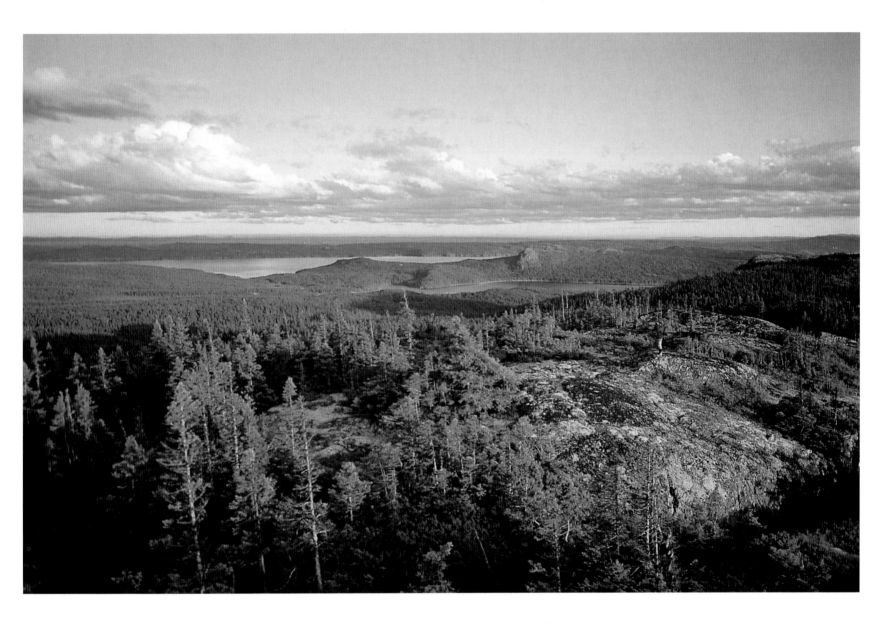

From Blue Hill Lookout, hikers gain a stunning vista across Terra Nova National Park to the Atlantic.

OVERLEAF –
Many of Newfoundland's seaside villages began as fishing outposts accessible only by boat. This isolation is partly responsible for the unique dialects spoken in the province.

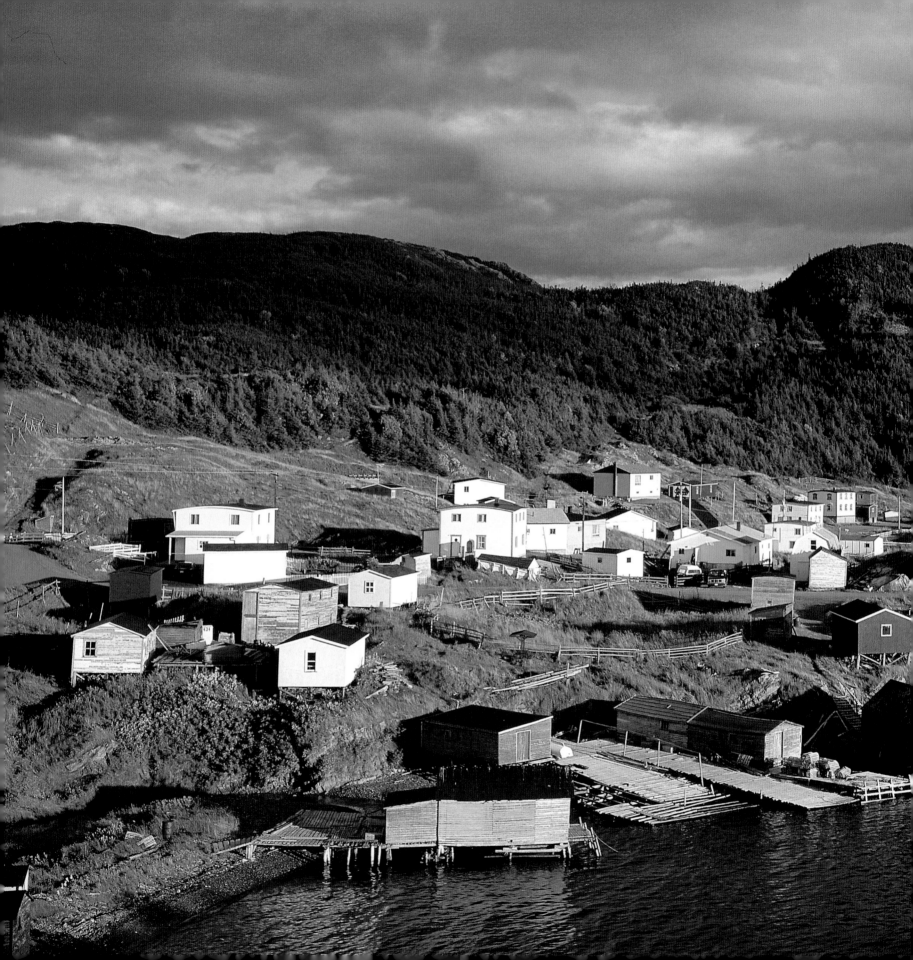

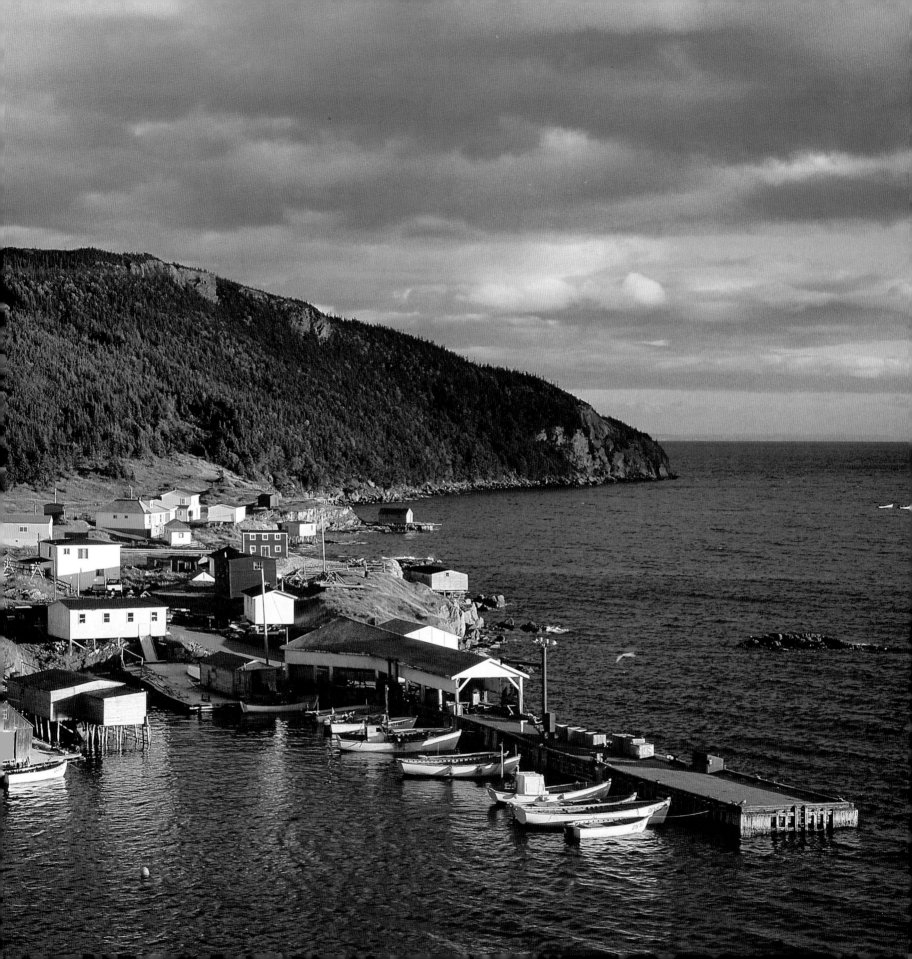

Photo Credits

CHRIS CHEADLE/FIRST LIGHT i, iii, 12-13, 16-17

DARWIN WIGGETT 5-7, 27, 28-29, 32-33, 78, 92, 94-95

IRWIN R. BARRETT/FIRST LIGHT 8, 10-11, 24-25, 31

KEN STRAITON/FIRST LIGHT 9, 23, 38-39, 72, 74, 76, 77

JESSIE PARKER/FIRST LIGHT 14, 36, 47

THOMAS KITCHIN/FIRST LIGHT 15, 18, 19, 20-21, 52, 60-61, 62, 64-65, 68

BENJAMIN RONDEL/FIRST LIGHT 22

JOHN SYLVESTER/FIRST LIGHT 26, 30, 34-35, 37, 40-41, 42, 43, 44-45, 46, 48-49, 50, 51 53, 54, 55, 56-57, 58, 59, 63, 66, 67, 69, 70-71, 73, 79, 81, 83, 84, 85, 87

G. PETERSEN/FIRST LIGHT 80

WAYNE WEGNER/FIRST LIGHT 82

LARRY MACDOUGAL/FIRST LIGHT 86

MARY ELLEN McQUAY/FIRST LIGHT 88-89

NIK WHEELER/FIRST LIGHT 90

B. AND C. ALEXANDER/FIRST LIGHT 91

WAYNE LYNCH 93